THEN & NOW

HULL AND NANTASKET BEACH

We're back.

Then & Now

Hull and Nantasket Beach

Committee for the Preservation of Hull's History

First published 2001

Published by Arcadia Publishing,
an imprint of Tempus Publishing, Inc.
2A Cumberland Street
Charleston, SC 29401

Printed in Great Britain.

Library of Congress Catalog Card Number: 2001089160

For all general information contact Arcadia Publishing at:
Telephone 843-853-2070
Fax 843-853-0044
E-Mail sales@arcadiapublishing.com

For customer service and orders:
Toll-Free 1-888-313-2665

Visit us on the internet at http://www.arcadiapublishing.com

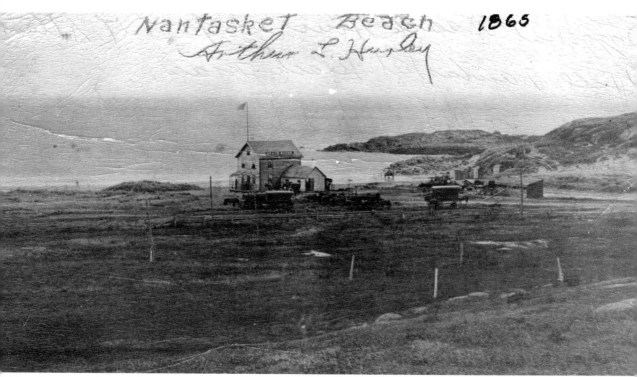

Don't you just wish you were there? Over the next 92 pages, we will do our best to take you back through time to Hull's forgotten past.

CONTENTS

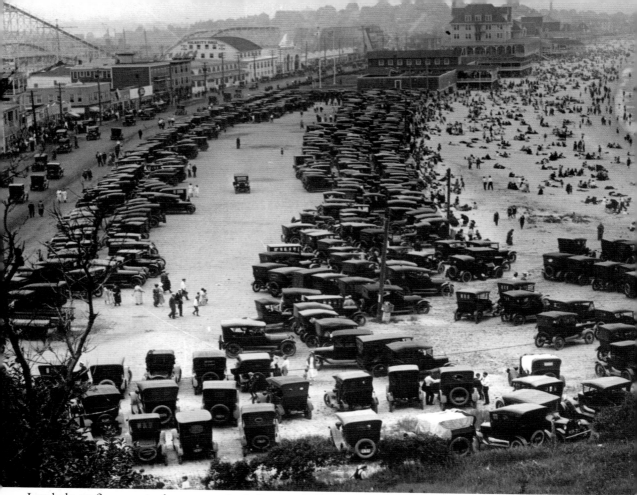

Just help us figure out where we parked. Our car is black.

INTRODUCTION

When the editors from the northeast office of Arcadia Publishing informed us that we, the Committee for the Preservation of Hull's History, would have the opportunity to put together a new book in their *Then & Now* series, we said, "Cool. Sounds easy." Right.

We sat down at the Old Town Hall in Hull Village to brainstorm early in January 2001, shaking off the confusion of the holiday season just past. Maybe we figured that being in a historic building would put us in the mood. We agreed right away that our second book would contain all new photography from cover to cover and would not duplicate *Images of America: Hull and Nantasket Beach* in any way. We knew that certain themes would have to be revived, as we did not have enough room to talk about all of Hull's hotels, people, and landmarks in the first book, but we knew, too, that the new book would provide us a great chance to showcase the things about our town that are special today.

We began searching the files of the Hull Historical Society for "new" old photographs and then began to format the chapters and figure out who would write what.

Then it happened. We were all happily, mindlessly, blissfully gazing with glassed-over eyes at images from the past, losing ourselves in history, when suddenly someone looked up and said, "Hey guys! When's 'then'?" A dozen mouths opened, but no words escaped before they shut again, as we all timidly thought to ourselves what the answer might be. You have not lived until you have dumbfounded a historian, his brow furrowing as his jaw bobs up and down. We all looked at the pictures in our hands and pondered the fact that certain buildings and sites in town had undergone numerous changes over time and that there could never be a clear-cut "then" that could encompass all we wanted to show about the way our town has grown. "Now" was easy. "Then" was hard.

Our next headache came when someone pointed out that if we were not careful, the book could easily turn into 96 pages of pictures of old buildings and the empty lots where they once stood. What about people? How many nonagenarians were there in town that could be pictured in both old and new photographs? Who was going to take all of the "now" photographs? We were, until that point, just a bunch of dumb historians.

So, we called for help. First, at a chance meeting at the annual luncheon of the Plymouth County Development Council, coauthor John Galluzzo threw a lasso around former *Hull Times* editor and classmate Chris Haraden, someone who had been on the Hull Historical Commission at 13 years old and obviously should be roped into this project. Then, responding to a plea for help in the *Hull Times*, our photography angel, Midge Lawlor, descended upon us to save the day.

With a roster of 12 major contributors to the book, we had more than enough authors, and with Peter Seitz as capable a photographer as a writer, we had plenty of picture coverage as well. We put out another call, this time for old photographs, stressing that the book should be a reflection of what the people of Hull want their history book to be and not the narrow vision of 12 people. Images came in handfuls.

Not every member of the committee wrote text for this book. Some handled the business end of the project, while others helped with layouts. Some snapped photographs, while some tracked down

memories. Every person contributed something to the work.

To the best of our ability, we think we conquered those problems that the book's broad themes threw at us. We hope that you enjoy this, our second collaborative project, and look forward to serving you again in the future through even more historical projects such as *Images of America: Hull and Nantasket Beach* and *Then & Now: Hull and Nantasket Beach*.

The Committee for the Preservation of Hull's History
Regina Burke • R. Francis Cleverly • John J. Galluzzo
Christopher J. Haraden • Janet M. Jordan • Myron Klayman
James B. Lampke • Midge Lawlor • Peter T. Seitz
Richard C. Shaner • Brison S. Shipley • Daniel J. Johnson

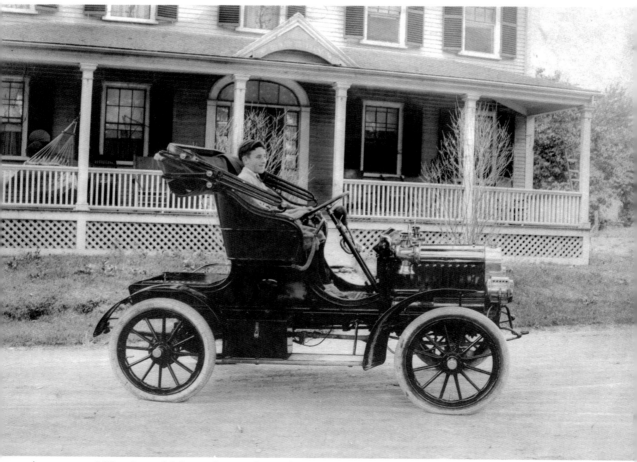

Away we go! Hop in and join us for another ride through historic Hull.

How many of us would still live in Hull if, by some mystical geological shift, it suddenly moved 20 miles inland? There can be no doubting the power of the sea to beckon us to its surface, depths, and edge. We sail on it, swim in it, and enjoy it in so many other ways. Some Hullonians make their living by it, while others have lost their lives to it. Our access to it will forever make Hull a tourist town, or "summer colony," as seasonal visitors roll in each June, July, and August as regularly as the tides. Then, in the colder months, the water's edge becomes all our own again. We can walk the beaches in solitude, collecting shells or whatever other magical gifts it may offer us as rewards for staying by its side all year long. We never seem to mind, as we stroll along, if we get a little sand in our shoes. What is irritating to some is beautiful to us. As we open *Then & Now: Hull and Nantasket Beach*, we will rediscover the reasons why we love our town.

Chapter 1

SAND IN THEIR SHOES

T he southern end of Hull is
 dominated by Straits Pond. Reinier
James, the brother of lifesaver Joshua
James, once claimed that his mother
sailed a boat out of Straits Pond and into
the ocean at high tide. In the 1890s,

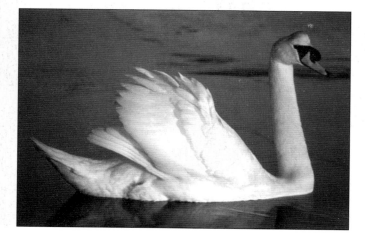

Cohasset resident Col. Albert A. Pope,
the founder of the Columbia Bicycle
Company and an avid yachtsman, put
together a plan to cut a path between
the pond and the sea off Crescent
Beach. He envisioned the pond as being
a safe harbor for yachtsmen stranded
outside the Hull peninsula during
storms, complete with a drawbridge to
allow for uninterrupted road service
between Cohasset and Hull. After the
Portland Gale of 1898, some residents of
the Gun Rock section of Hull had to
search the pond to find their homes, as
gusting winds of up to 120 miles per
hour drove houses from their
foundations. Today, relatively few yachts
or houses make their way into the pond.
Where would they fit, anyway, among
all of the swans? It is now designated an
area of critical environmental concern,
and the townsfolk of Hull are very
protective of Straits Pond.

No matter what season of the year it is, Gun Rock Beach, tucked away in the background of the image below, always captures the imagination, but there is little left to imagine in regard to the history of the spot. As picturesque as it is, one can sit on the beach and look up to the hills and time-travel back to the late 1800s, when Victorian hotel-goers sat on the verandas of the Pacific House and others, gazing down upon the beautiful curved beach below. During the aforementioned *Portland* Gale of 1898, Joshua James and his band of lifesavers launched the surfboat *Nantasket* from the protected cove and rowed south to Black Rock Island to save three men from the wreck of the *Lucy Nichols*. During Prohibition, rumrunners loved the hidden nature of the cove. In one famous encounter, the Coast Guard learned that the rumrunners would be coming in to Gun Rock, so it sent a team ahead to intercept them. Putting their guns in the backs of the rumrunners, the coastguardsmen soon felt cold steel

against their own backs—pistols held by rumrunners covering their friends. Then the Hull police showed up and caught the rumrunners by surprise. Who knows what might have gone on here in the age of piracy. Adventure, quietude, the joys of summer—Gun Rock Beach has seen it all.

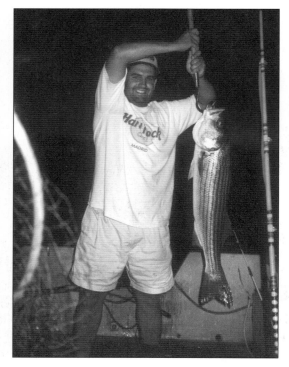

Even today, Hull is known as one of the best spots from which to view the annual migration of the coot, or scoter duck. Yet, it seems that we hardly even know that they are there, as they fly by in formations with old-squaws and eider ducks. One hundred years ago, coot stew was a staple of late-autumn menus in Hull. As a matter of fact, most of the hotels that stayed open into the fall season in Hull did so by offering "the finest coot stews" around, a surprising fact when you look back to old cookbooks. Many coot stew recipes called for a coot and an old shoe to be boiled in a pot for an hour. At the end of that hour, you were instructed to throw away the coot and eat the shoe. The problem was that coots were, and are, bottom feeders that do not dry their wings like cormorants. Therefore, they retain an oiliness in their feathers that becomes a part of the stew when boiled. Coauthor John Galluzzo, left, pulled this 40-inch, 25-pound striped bass from the bottom on his first Boston Harbor fishing trip in 1997 and then promptly retired from the world of fishing.

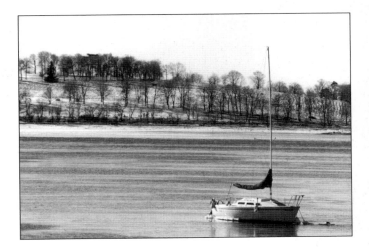

From the north end of the peninsula, we have the Boston skyline and the islands of Quincy Bay and Boston Harbor. From anywhere along the eastern side, we have the views of Boston and Graves Lighthouses. All along the coast we can watch the constant parade of boats, large and small, as they pass in and out of protected harbors. From Sunset Point, though, we have an even more enchanting view of World's End. Laid out by landscape architect Frederick Law Olmstead in 1893, the Trustees of Reservations' World's End Reservation was originally the farm of John Brewer and family. Before becoming the sanctuary it is today, it almost ended up as the home to either a nuclear power plant or the United Nations. How different would life in Hull have been today in either case. There can be no doubt as to why the competitors to Paragon Park, who came to town in the first decade of the 20th century, planned to build their own park, Dream City, on Sunset, or Nantasket, Point. Has anybody figured out where it gets its name? From the beautiful sunsets that fall directly over its westernmost tip.

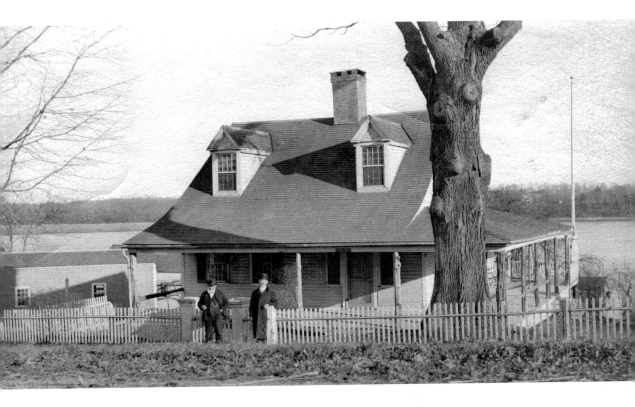

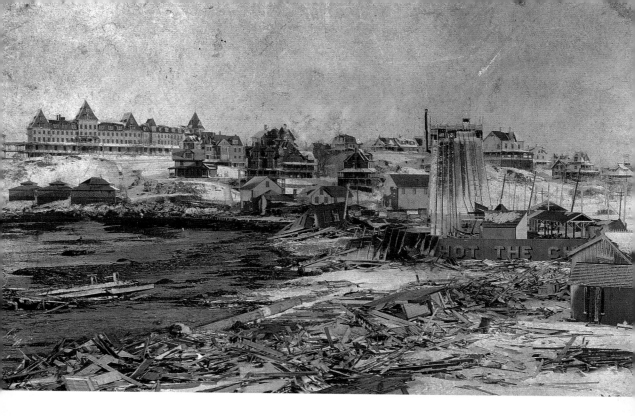

The biggest attraction in Hull in 1898, by far, was the Chutes water slide at the base of Atlantic Hill. Thousands of thrill seekers visited the shore that year to lay claim to the boast,

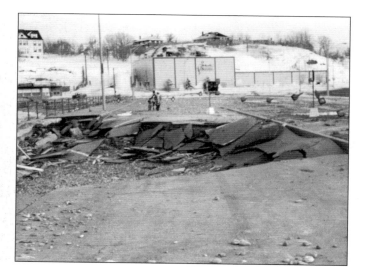

"I shot the Chutes at Nantasket Beach." On November 27, 1898, old Boreas pushed his way to the front of the line and shot the Chutes to pieces. The storm that claimed more than 500 lives and 350 ships from Nova Scotia to New Jersey left Nantasket Beach an unbelievable mess. Coal—11,000 tons of it—washed ashore from six wrecked barges and intermingled with the remains of hotel boardwalks and summer cottages alike. Hull's old-timers declared it the most destructive storm since the Minot's Light Gale of April 16, 1851, and all agreed that there would never be a storm as powerful again. Then came the Blizzard of 1978. Some Hull streets became rivers, while others became impassable with snow. Residents picked lobsters out of their hedges and huddled together in the Hull Memorial School until it was safe to return home. Some had no homes to return to.

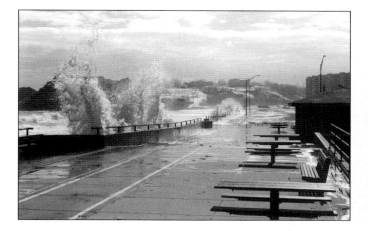

Just 13 years later, on Halloween Day of 1991, the No-Name Storm (which actually has three names, including the Halloween Storm and the Perfect Storm) slammed the Boston area again. The wave pictured below crashed its way over the Gun Rock section of Hull, which always seems to be the hardest hit during nor'easters. The sand dunes along the alphabet streets disappeared, and we once again saw the presence of the Massachusetts National Guard and their heavy equipment, as we had in 1978, but with each storm we learn something new. Now we plant beach grass in the dunes to stabilize them. Just to show us that she is paying attention, Mother Nature gave us another show of power on March 5, 2001, with flooding rains, heavy snow, and rising tides. She can give Hull all she wants; we will always come back and rebuild. Sometimes, as shown in the picture above, the surging seas in the aftermath of a storm can be spectacular.

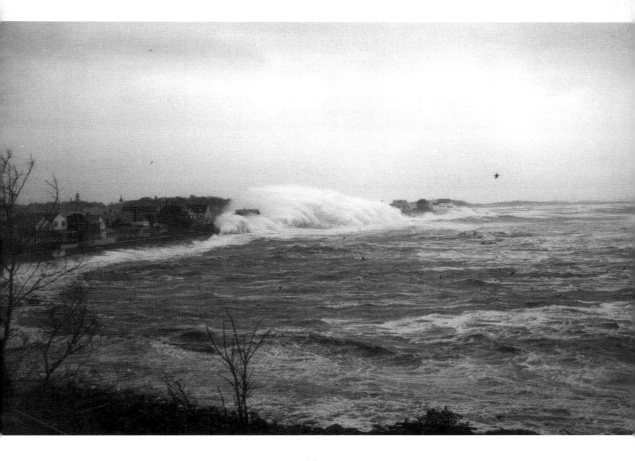

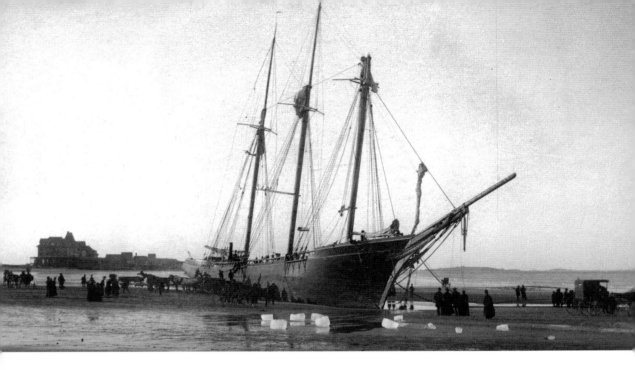

Storms cause shipwrecks even today. Back on November 25–26, 1888, one of Hull's famous storms tossed several ships onto the peninsula, sending Humane Society of the Commonwealth of Massachusetts volunteer lifesavers out for 36 hours of continuous rescue work. Joshua James, then 62, led his crew to six different ships during the storm, saving 28 sailors. The *Mattie Eaton,* above, stranded high and dry on Nantasket Beach at the base of Atlantic Hill. Eight years later, on December 16, 1896, James led the rescue effort to the plaster-carrying schooner *Ulrica*; James was by then the keeper of the Point Allerton Life-Saving Service Station crew. After failing at launching their surfboat and nearly pitchpoling it (flipping it end over end), the lifesavers fired a line-throwing gun to the ship in hopes of rigging a breeches buoy to effect the rescue. The cold and tired sailors aboard the *Ulrica*, though, could not handle the lines. The lifesavers then got back in their lifeboat, hauled their way out to the ship by use of the line stretching from ship to shore, and eventually saved all of the men aboard. A chunk of hardened plaster with the name of the ship and the date of the rescue is on exhibit at the Hull Historical Society's Old Town Hall.

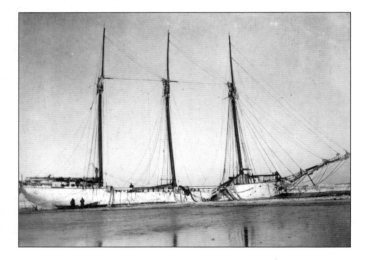

On February 20, 1927, the five-masted schooner *Nancy* ran aground on Nantasket Beach. Osceola James, the only surviving son of Joshua James, called out the aging Massachusetts Humane Society crew to man the surfboat *Nantasket* one final time, rowing out to the vessel and saving the crew. The *Nancy*, pushed up even higher onto the beach by a later storm, never floated again. During the 1930s, it served as an advertising billboard for Nutro drinks, a jungle gym for local youths and sightseers, and flammable material for pyromaniacs (by the end of the 1930s, the *Hull-Nantasket Times* had recorded 37 fires aboard the abandoned hulk). In the end, a Works Progress Administration crew burned it down to the keel, and although today the age of sail has passed and technology has eased the stress of navigation, in the

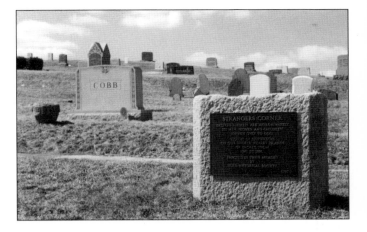

old section of the Hull Village Cemetery we have one constant reminder of Hull's shipwreck past. Strangers Corner, a mass grave of more than 100 lost and never-identified sailors, is marked by the stone depicted above.

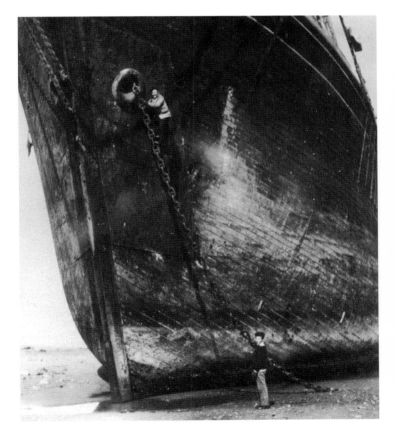

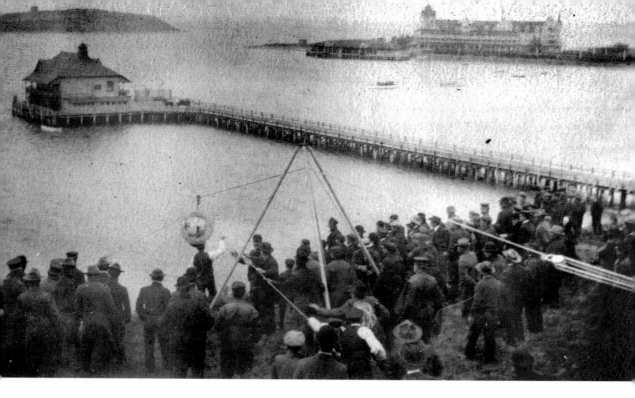

The tradition of those early lifesavers remains, though. Shore-based lifesaving efforts began on the Hull coast in 1787, when the Humane Society of the Commonwealth of Massachusetts placed one of its first three houses of refuge on Nantasket Beach. Each such house held those items necessary for survival after a shipwreck, from blankets and dry clothing to food and water to wood and coal for a fire. In 1807, the lifesaving organization built its first lifeboat in Nantucket, placing it in Cohasset and calling for volunteers to man it in times of trouble. Hull got its first boats in the early 1840s, and the men who manned them soon became known across the country for their daring rescues. Around the beginning of the 20th century, lifesaving crew captains from around the state began meeting annually to celebrate their successes and share their knowledge. In the 1905 photograph above, Capt. Osceola James and the Hull volunteers demonstrate a breeches buoy rescue from high atop the southwestern slope of Hull Hill, mounting their A-frame on the property of F.C. Welch. The Massachusetts-American Yacht Club is in the background, on approximately the same site of today's Coast Guard boathouse.

In 1848, the federal government appropriated $5,000 to begin building lifeboats and station buildings based on the infrastructure then in place with the volunteer service in Massachusetts. Although slowed by the Civil War, the U.S. Life-Saving Service solidified in 1871 as part of the U.S. Revenue Cutter Service, breaking away on its own in 1878. In 1889, Joshua James became the first keeper of the Point Allerton Life-Saving Station, serving there until his death on March 19, 1902. At its high point in 1914, the Life-Saving Service had 279 stations around the country, on both the East and West Coasts, the Great Lakes, and a floating station on the Ohio River. In 1915, the Life-Saving Service and the Revenue Cutter Service again merged, now forming the U.S. Coast Guard, the organization we know today. That service later absorbed the Steamboat Inspection Service, the Lighthouse Service, and the Bureau of Navigation, and although their missions have been added to over the years, their principal reason for existence is still the

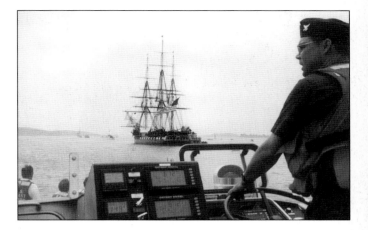

saving of lives at sea. Today's young coastguardsmen at Coast Guard station Point Allerton still embody that same spirit that shone forth from Joshua James over a century ago. Above, Craig D. Bitler, chief warrant officer, who was the commanding officer at Point Allerton from 1998 to 2001, steers the station's 47-foot motor lifeboat on a security detail for USS *Constitution*.

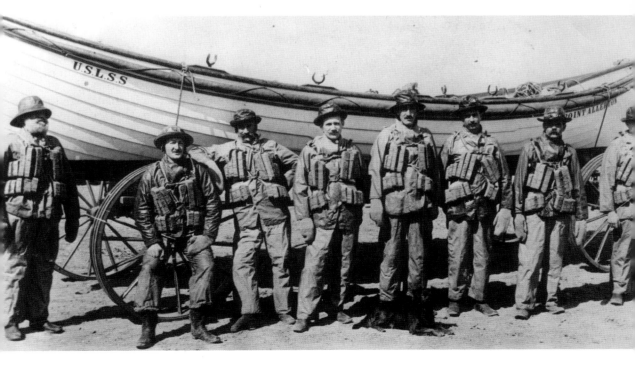

Not every Hull boater has been at the top of his game at all times. Every once in a while, what looks to be a perfect mooring might just be too good to be true. For the most part, whether a lobsterman (Hull's Nantasket Beach Saltwater Club is home to the Massachusetts Lobstermen's Association), a yachtsman from the Hull or Spinnaker Island Yacht Clubs, a local fisherman, or any other pleasure boater, the locals stay out of trouble on the water. As early as 1628, the people of Plymouth began consulting the residents of Hull on fishing matters, and, by the end of the 1840s, Hull was famous not only for its lifesavers but for its harbor pilots as well, many of whom held the surname Cleverly. Even today, Hull residents act as tugboat and fireboat captains and coastguardsmen as well. Rick Barone, chief boatswain's mate, serves as the executive petty officer for the Point Allerton Station, holding the position his father once held years ago. Between pilots, the Coast Guard, and a proud harbormaster's office, Hullonians such as fisherman Capt. Bob Dever are well supported on the water.

The days of the Hull steamboat line are long gone, but that memory will linger forever. Although a writer could go on for pages talking about the technical aspects of steamboat technology and the differences between the various boats that plied the waters between Hull and Boston for more than a century, what will always be with us is the simple elegance of the white ships against the colorful summer background, and the notion of an open-air trip to the city. Thousands enjoyed such excursions every year, escaping the claustrophobic confines of the city's streets in exchange for the natural, broad sandy beaches of Nantasket. Tourists still flock to the shore each year in the summertime, some of whom still make the trip by boat, but as the city of Boston has grown and transportation patterns have changed, many

commuters find it easier to park their cars in Hull and head for the city on a commuter boat for work, keeping alive a Boston-to-Hull boat run that has been in place since as early as 1818.

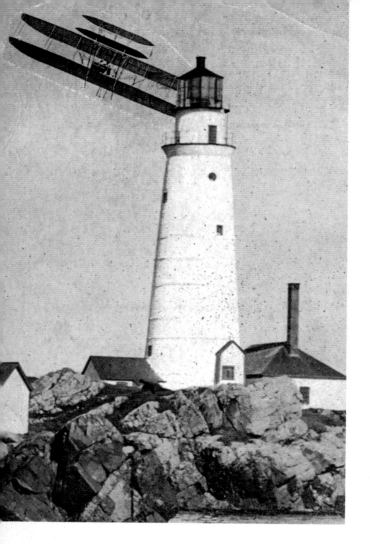

as a halfway point, and Flying Santa, from William Wincapaw to Edward Rowe Snow to Hull's George Morgan, has been visiting the light since the 1930s. In 1928, Francis S. James became the first Hull policeman to die in uniform, after seeing a plane that had flown around the world fly over Boston Light and uttering, "Isn't that a beautiful sight!" before passing away. As we look to the future, we know that Boston Light will remain the focus of our region's historic and scenic beauty, and that we, like Rick Himelrick, boatswain's mate 1st class and the most recent keeper of Boston Light, will stand ready to protect our beloved shores.

Standing on what was once Hull real estate, Boston Lighthouse on Little Brewster Island is today the last U.S. Coast Guard-manned light station in America, as well as the country's oldest light station. Built in 1716, the lighthouse has witnessed most of American history and itself was a casualty of the Revolutionary War. After one battle at the lighthouse, Continental troops transported a captured British marine to Hull, leaving him to be buried by Lt. William Haswell and his daughter, Susanna, on what is now the grounds of the Hull Public Library. Although the above postcard is an obvious cut-and-paste masterpiece, Boston Light has been the scene of many memorable bits of aviation history. Air races from Squantum used Boston Light

The first of Hull's famous resorts, opened in 1826, remained the final link to the hotel era until 1986. The Sportsman, as it was known originally, was a favorite refuge for hunters from throughout the region. Arthur Pickering acquired the lodging house in 1868, after Paul Worrick's death. Pickering sold the inn to wealthy bank vault manufacturer George Damon. The Damon family used the mansion as a summer home for 25 years before it became a resort once again. The Worrick was famous for its high-stakes card games before World War I. During the 1920s, the luxurious inn was reputed to have been one of Hull's many speakeasies. Following Prohibition, the mansion, renamed the Greystone Lodge, was known for its lavish dinners. The Worrick became a popular function hall after the Eastman family purchased the property in 1939. The original two-story mansion was

Chapter 2

CASTLES BY THE SEA

expanded over the years, when it was connected by a long hallway to a newer building. Although primarily a country music lounge in later years, the Worrick Inn, painted pink, was still hosting wedding receptions, testimonials, and class reunions when it burned to the ground in the early-morning hours of June 11, 1986.

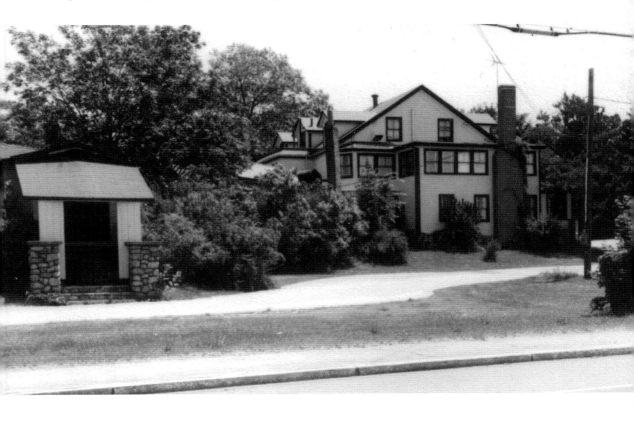

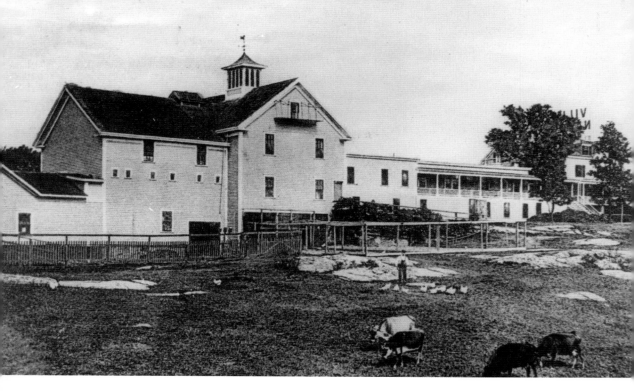

Built on the crest of what is now Shore Garden Road, the Villa Napoli was once the summer estate of R.H. Stearns, owner of a large downtown Boston department store. Cows had grazed on Atlantic Hill in the 1840s, but pastureland was scarce by 1895. Tax records for that year indicate

that Stearns had six cows, two horses, and a pony, as well as chickens, on what was possibly the last farm in Hull. The 15-acre property included a barn, stable, wood house, and bowling alley. Unhappy with the influx of amusements into the area, Stearns sold his estate to Alfred DiPisa, who expanded it into a luxurious summer resort. DiPisa was proprietor of the Hotel Napoli in Boston at the time. The seasonal hotel business declined sharply after World War I, as more families bought summer cottages. A garage had replaced the stable by then. Recognizing that the days of lavish resorts had passed, DiPisa sold the hotel to William McPeak. McPeak's Shore Gardens was a popular restaurant and function hall before it burned in 1932. Remnants of the original building are still visible in the copse of trees behind the dark vehicle in the present-day photograph.

The Rockland House, built in 1854, continued to expand as Nantasket Beach increased in popularity. The original hotel was 60 feet long, with 40 rooms. Coaches brought the first visitors from Hingham. After the steamboats began arriving in 1868, the hotel expanded to 160 rooms. A plank walk was built from Nantasket Pier directly to the hotel in 1874. Ten years later, the hotel was 275 feet long and had 200 guestrooms. The Rockland House was a true resort, offering its patrons golf links, tennis courts, basketball hoops, roulette wheels, dice tables and championship billiards. The neighborhood changed in 1905 when an amusement park was built at the bottom of the hill. A consortium of Boston businessmen bought the Rockland House and surrounding area with the intention of building a permanent world's fair. Paragon Park was a one-day vacation, catering to a different clientele

from those who could afford to escape the city for weeks at a time. The grand hotel's patrons had moved on to other resorts long before the massive hotel burned during a snowstorm in 1916. Three family homes are now where the hotel once, stood at the corner of Park Avenue and Rockland House Road.

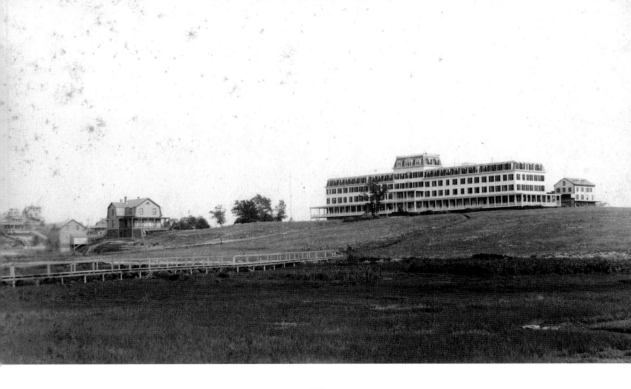

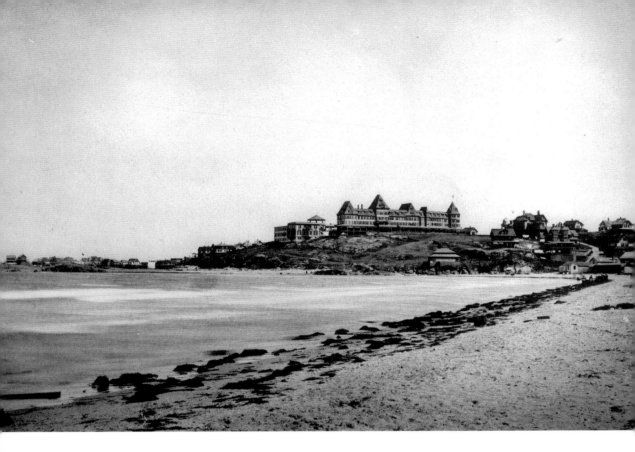

With its magnificent architecture and commanding view, the Atlantic House was the most famous hotel in New England for two generations. The opulent resort featured an elaborate dining hall, a gigantic ballroom, numerous private dining rooms, roulette parlors, several bars, and mahogany tables and chairs on the verandas. Daily room rates were eight times the cost of boat fare from Boston to New York. The first building on the site was a two-story house built in 1845 to accommodate parties and picnickers. When this picture was taken in 1898, the hotel had 174 rooms. In later years, two additional bathhouses and a wooden walkway to the beach were added. The Damon family sold the hotel in 1924, but the coastal rights were still in dispute when the hotel was demolished by fire in less than hour on January 7, 1927. The Atlantic Hill Condominiums were the first of a new wave of large-scale condominium developments that swept Hull in the mid-1980s. Several large private homes lined the top of the hill in the years between the hotel and the condominiums. In recent days, another large development was being built on the far side of Atlantic Hill .

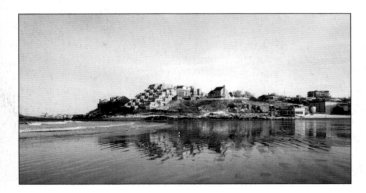

Several hotels overlooked the ocean between the magnificent Black Rock House on Jerusalem Road and Atlantic Hill during the later part of the 19th century. The Pacific House, the Waverly House on Centre Hill, and the Wentworth at 20 Meade Avenue appealed to those who desired a quiet and more restful location than the hotels on Long Beach, as Nantasket was referred to then. Built in 1854 on what is now Stony Beach Road, the Pacific was designed to attract fishermen. For the convenience of its guests, a small bridge was built to Table Rock—a large, flat stone several feet off shore, where patrons could fish without a boat. The Pacific House was expanded in 1877 to include 48 guestrooms and an "annunciator," a forerunner of the intercom, which allowed communication with every room. The 100-foot frontage was entirely surrounded by verandas to take advantage of the view of Gunrock

Beach. The Pacific changed hands many times before being taken over by Michael H. Burns. The Pacific flourished under Burns's management, primarily because of gambling, from 1903 until 1914, when Burns moved on to manage the Oakland House, which later became the Mike Burns Inn.

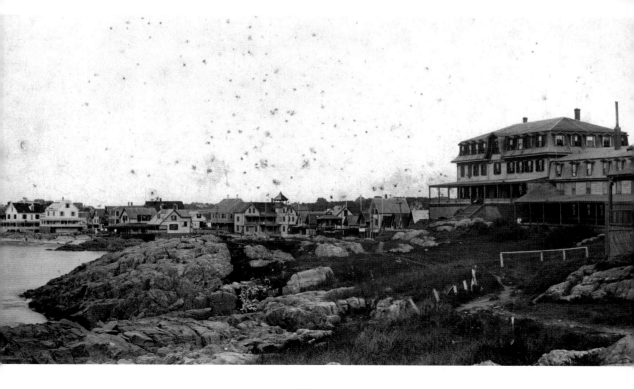

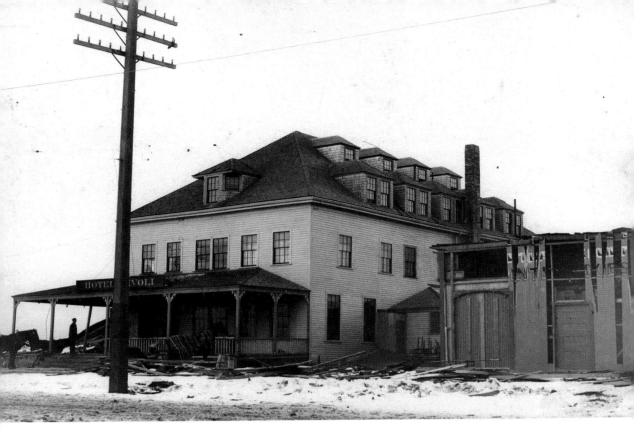

Steamboats and the railroad brought masses of people to the beachfront in the 1890s. The profusion of beer halls, side shows, and houses of questionable reputation that pandered to elements of those crowds had undermined Nantasket's genteel atmosphere long before Paragon Park was built. When the Metropolitan Park Commission was given authority over the first mile of Nantasket in 1899, its first objective was to move private businesses off the beach. The Hollis and Montasco Hotels, just north of Atlantic Hill, burned together less than two weeks after the Parks Bill ceded the beach to the Commonwealth of Massachusetts. North of the Hollis was the Tivoli, where it was said that a man could get a drink any hour of the day or night. The Tivoli was sold for $300 in 1900 and moved to Nantasket Road, where it became the Nantasket Point Hotel. The large, state-run bathhouse that replaced the hotel was popular for many years. After the bathhouse moved south in 1930, the Tivoli Gardens restaurant was built on a pier at the site. The restaurant was eventually replaced by a refreshment stand before it was destroyed by a hurricane, along with the pier, in the late 1950s.

The numerous rooms for rent along the beachfront that survived into the 1950s were a testament to Nantasket Beach's continuing popularity for summer vacations long after the era of the grand hotels. In one remarkable turn of events, the Tivoli, which had been moved by barge to Nantasket Road, returned to its old neighborhood a few years later as the Richards Hotel. Two hundred yards from where it had been, the original Tivoli building was relocated across the street from the Nantasket Hotel. To appeal to a more transient crowd at the new location, half the bottom floor was converted into a long, narrow barroom called Duffy's. The Richards Hotel and Hurley's Hurdlers, as the adjacent merry-go-round was known, were torn down in the early 1950s to clear the way for Funland amusement park. Despite its foreboding atmosphere, Duffy's survived into the 1970s by featuring

live entertainment. Funland continued as a satellite amusement park until shortly before Paragon Park was sold in 1985. The arcade area of Funland then became the Dream Machine and a 40-foot-high water slide was built where the outside amusements had been. A miniature golf course replaced the water slide in the 1990s.

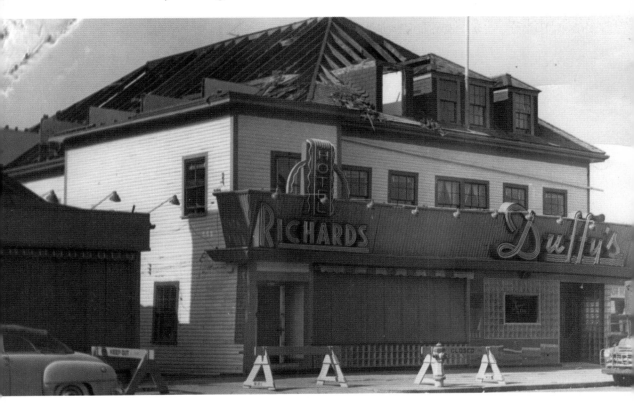

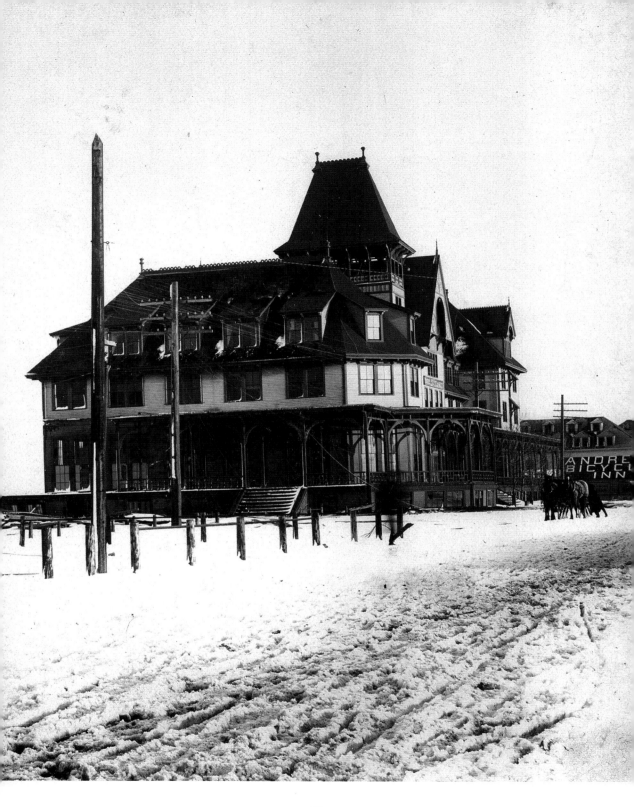

Directly in line with Steamboat Wharf, the Rockland Café was affiliated with the Rockland House when it opened in 1871. It was remodeled and expanded after a fire in the 1890s and, under new management, renamed the Nantasket Café. The arch at the end of the café was known as the "Entrance to the Beach." In 1899, a pavilion was built to connect the café to the Hotel Nantasket, which had been built 20 years earlier. Completion of the pavilion created a 3,000-foot-long promenade, lined with seats, running parallel to the ocean. After having been boarded up for years, both the café and the hotel were torn down in 1955 to provide parking for the tourists who then flocked to Nantasket by car rather than train. The sole survivor of the grand promenade is the arcade-like building that connected the two hotels. The Nantasket Pavilion was renamed

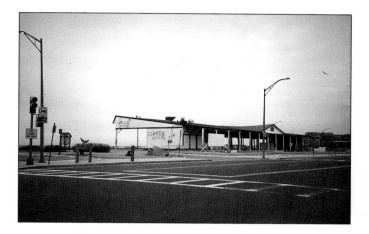

for bandleader Bernie King, who helped bring live music back to the beach in the 1950s. Hull's annual Chowdafest and weekly summer concerts featuring swing bands still draw crowds to the old pavilion.

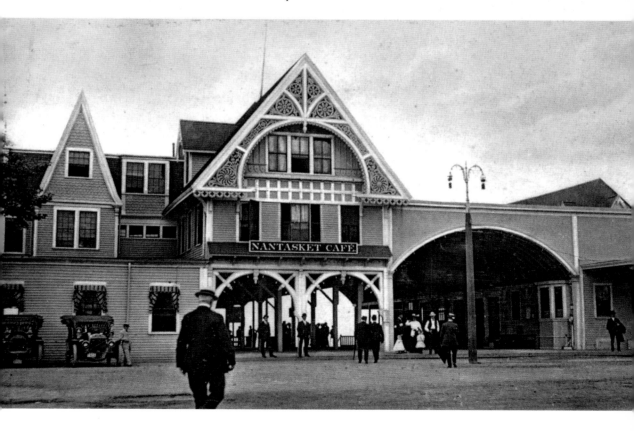

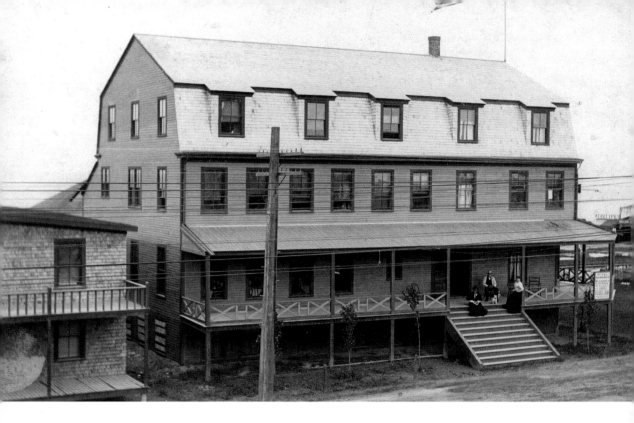

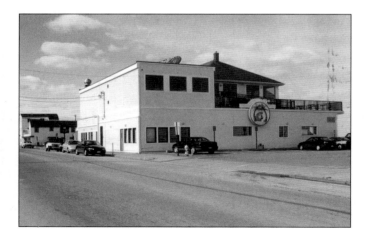

Northof Steamboat Wharf, several smaller hotels offered food and lodging to those who could not afford the more lavish surroundings of the grand hotels. The Brunswick, pictured here, was one of several hotels between Sagamore Hill and Steamboat Wharf in the 1890s. South of the Brunswick, on the beach opposite Bay Street, was the massive Ocean View Hotel. The Ocean View could seat 800 for its famous clam bakes, done Rhode Island style, with clams steamed on heated rocks and covered with seaweed. The Ocean View also had 100 guestrooms. The Commonwealth of Massachusetts took the Ocean View by eminent domain in 1900 as part of its program to eliminate all buildings east of the railroad tracks. After the Brunswick burned, 258 Nantasket Avenue became home to a number of businesses over the years. The original Angelo's Pizzeria was there in the 1950s before moving across the street. Surfside Pharmacy operated on the site for 20 years before moving to the Kenberma area. The Sands billiard parlor shared the first floor with the pharmacy. Several apartments were on the second floor. Schooner's Restaurant replaced the Sands before the Red Parrot opened. The second floor of the Parrot is now the most popular function hall in town.

During the 1950s and 1960s, the Surf Ballroom at 296 Nantasket Avenue featured more headline entertainers than Hull had seen in 50 years. The Ocean Garden restaurant and dance hall had been popular at this location in the 1930s, but the opening of the Surf was considered the dawn of a new era. To provide additional parking, new owners William Spence and Jack Scott tore down the adjacent Beach House Hotel and the 70-year-old Revere House. Guy Lombardo and his Royal Canadian Orchestra were featured on opening night at the Surf, June 14, 1957. The property continued to evolve over the years. The ballroom days were over when the Surf became Uncle Sam's in the 1970s. The Vogue nightclub replaced Uncle Sam's, but business continued to decline and the place closed in the early 1990s. The ceilings were literally falling in when the last tenant, the cable company, moved out

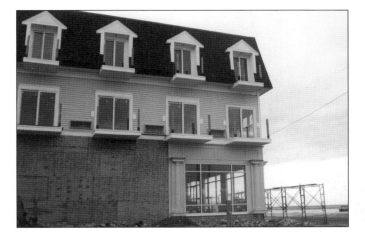

and turned community television over to the town in 1998. As this book is being written, Hull's first new hotel in decades is being constructed on this site, bringing with it a sense of hope that this area will once again become a mecca for visitors from throughout the region.

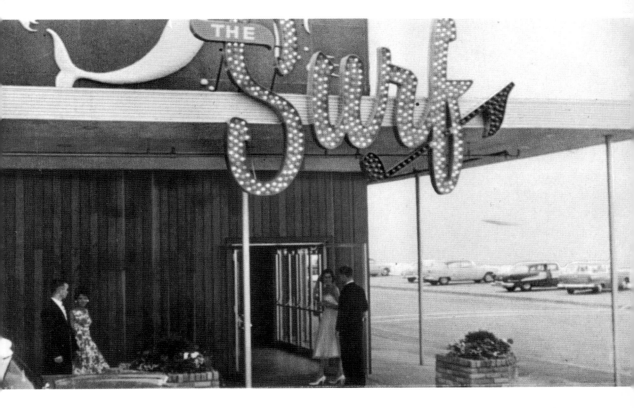

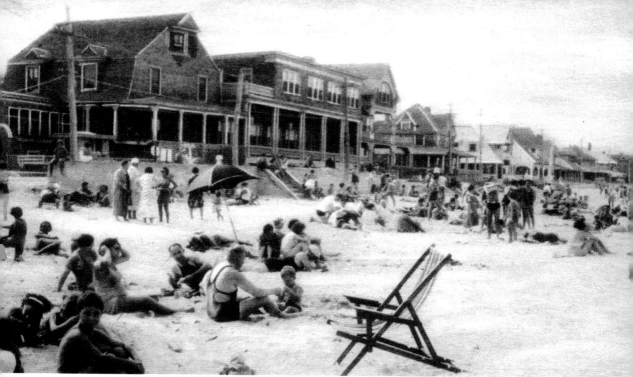

The population of Hull began to expand dramatically in the later half of the 19th century. Once visitors experienced the peninsula's natural beauty, more and more decided to visit for longer than a week or two. The first phase was summer cottages, which had begun to lessen the demand for resort hotels by the 1890s. Those who wanted to spend the season bought cottages they could return to every year. Enough people still came to Hull for short stays, however, to keep several smaller hotels in business for decades. A short distance from the Bermaken Hotel, which is now a rooming house, was the Rose Gordon, located on Beach Avenue between Kenberma and Alden Street. The Rose Gordon, the building with the flat roof, above, was renown for its dining room. Renamed the Golden Sands, the hotel closed in 1971 and became a private home, which burned in 1983. The second phase of the population shift was in full swing by then, as people who summered in Hull decided they did not want to leave, even in winter. The year-round population continues to increase with each summer cottage converted into a permanent home.

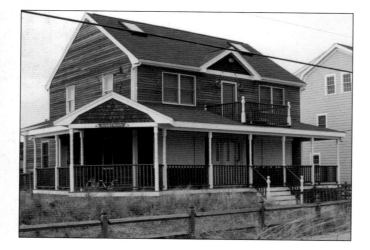

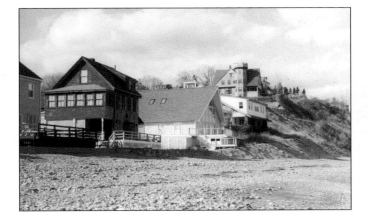

King's Handbook of Boston Harbor, published in 1888, contains this description: "A strong and steadfast arm, which, bent on guard, protects Boston Harbor from the easterly gales, is the long peninsula of Hull. The shoulder is Atlantic Hill; the biceps, White Head; the sharp elbow, Point Allerton; the tip of the hand, Windmill Point." If that analogy rings true, then the Nautilus Inn was where the arm bent, at the base of Allerton Hill. The Nautilus was a popular resort from 1910 until a mysterious fire destroyed it in May 1955. Seventy-five feet long and 50 feet wide, the green-painted Nautilus had 50 rooms and a dining area that seated 135. The circular drive to the main entrance and the tennis courts are out of sight in the view below. The A-frame house next door, now with a second-floor addition, is still standing. Just up the hill from the Nautilus, between the A-frame and the house with the turret, was the Atlantic Club, another even larger resort. The Atlantic later became St. Anthony's Villa, a Catholic retreat house, before it ,too, burned.

Nautilus Inn, Ocean Front, Allerton, Mass.

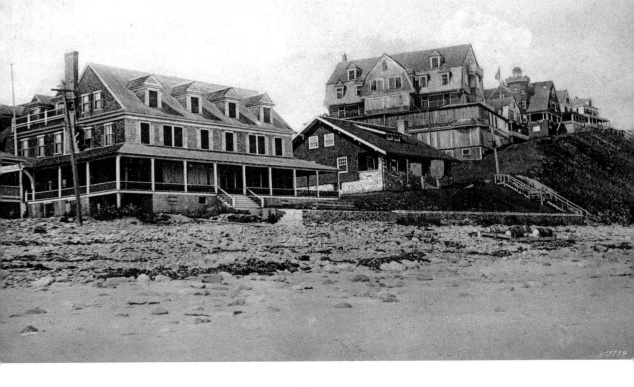

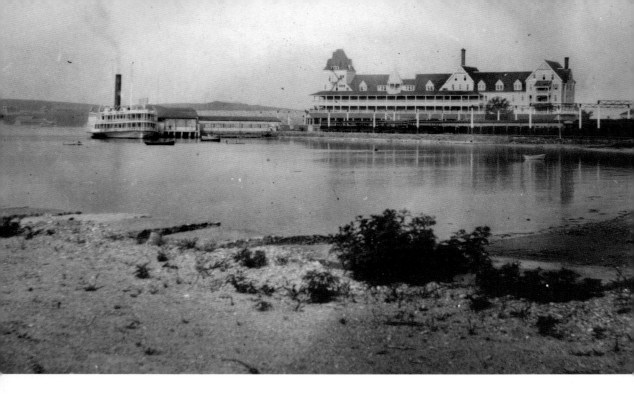

The Mansion House, built on the salt flats, was the first hotel on historic Windmill Point, operating from 1848 to 1870. The Pemberton Hotel, built in 1881, was an impressive example of Queen Anne-style architecture, with towers, gables, balconies, and piazzas. Isolated from the rowdier crowd at the south end of town, the Pemberton catered to an affluent clientele. Renovations in 1907 made the hotel even more luxurious. By then there were 200 finely furnished guestrooms, each with a water view, wine vaults, billiard tables, elevators, a ballroom, and dining halls. Orchestras provided music for dancing every night; there was a military band on Thursdays and fireworks every Wednesday and Saturday evening. An outdoor swimming pool with 50,000 gallons of ocean water, steam heated to 70 degrees, was available to guests of both the hotel and the nearby Pemberton Inn. Boarded up for decades, the Pemberton was razed to make way for Hull High School in 1956. School buses have replaced the trains, but commuter boats still arrive at the pier.

Cigars, Moxie, chocolates, groceries, and paint—just a sampling of the products for sale at Fairbanks's store at 301 Nantasket Avenue and a vivid illustration of the strength of Hull's businesses at the beginning of the 20th century. Poring over old photographs and maps, it is amazing how many retail establishments, restaurants, and other service businesses once populated the peninsula. Some were seasonal, catering to the town's large summer population; others were year-round spots that were an integral part of the fabric of the neighborhood. Observing the changing face of the town's business community is fascinating for both Hull natives and transplants, and this chapter explores only a small part of the evolution of the local commercial landscape.

Chapter 3
THERE'S NO BUSINESS LIKE HULL BUSINESS

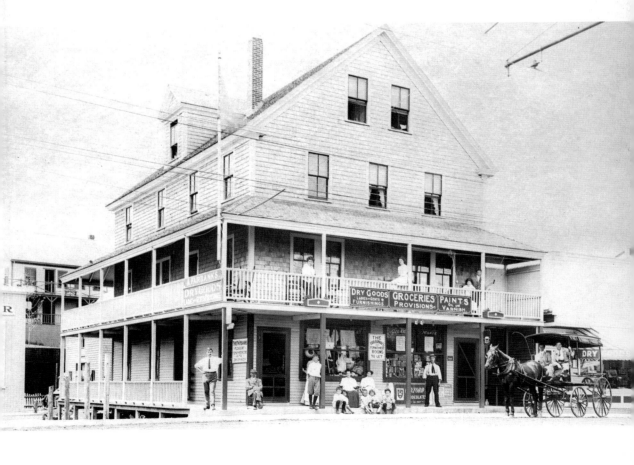

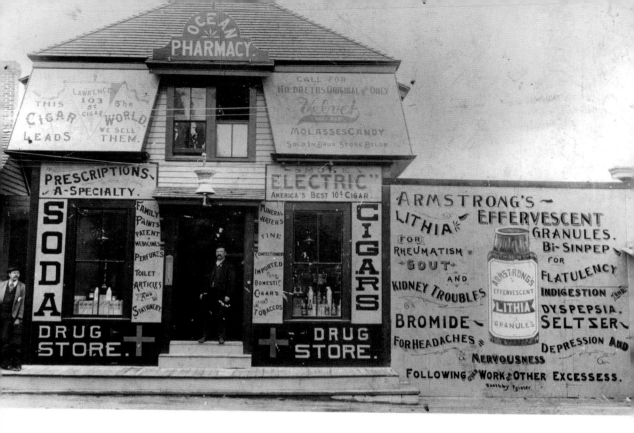

In the 1890s, the Ocean Pharmacy appeared to sell the cure for whatever ailed you. The pharmacies of today might not make such grandiose claims about their products, but in the years since the Ocean's debut in 1895, there have been numerous apothecaries up and down the peninsula. The Ocean Pharmacy was located on Nantasket Avenue, near the corner of Wharf Avenue. Many people have fond memories of McCormick's Rexall Drug at the corner of L Street, which still had its old-fashioned soda fountain when it closed in 1980. Hull's current drugstore is Nantasket Pharmacy, which moved into a brand-new building at 480 Nantasket Avenue in 1991. The store, owned by pharmacists Rocky and Jane Tenaglia, previously was a few blocks north in the Kenberma business district. The pharmacy traces its lineage back to Duprey Drug, which advertised itself in the early part of the century as Hull's only year-round drugstore. Duprey started at 297 Nantasket Avenue; it moved across the street to 254 Nantasket Avenue and later was renamed Surfside Pharmacy. In the 1980s, the store, then known as Moulton's Pharmacy, adopted the Nantasket name when it moved to Kenberma in the 1980s.

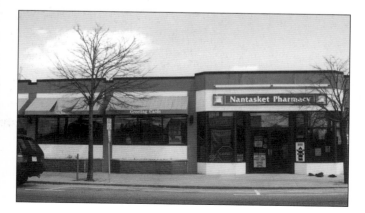

Quite a bit of commerce was taking place in the early 1900s view, below, of the stores at the base of Allerton Hill. The taller building in the center of the photograph had the Allerton Grocery and Provision Company on the first floor, sandwiched between Walter L. Conwell's store on the right and the Allerton Post Office on the left. Several modes of transportation also converge in this scene—early automobiles share the street with a horse-drawn delivery wagon, and the photographer was standing just steps away from the Allerton railroad station. The current view, right, shows the same buildings at 839–845 Nantasket Avenue, which are now apartments overlooking Allerton Harbor and Sunset Marine. The post office building is gone, but the structure to the far left in both photographs survives; in the 1980s, a cylindrical addition was built and the Lighthouse Restaurant opened on the bottom floor. The buildings and marina

facilities are currently owned by businessman William Kelley. In the foreground the stone and flagpole that anchor the triangle at Nantasket Avenue and X and Y Streets are Capt. Joshua James Park, named for Hull's most famous lifesaver.

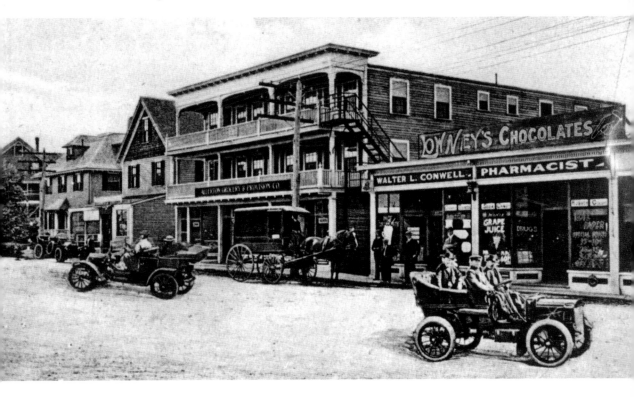

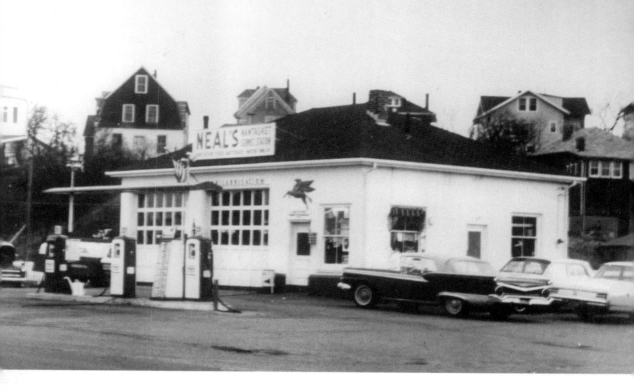

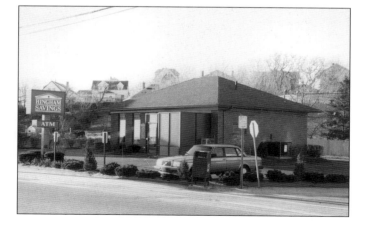

Most Hullonians are familiar with Neal's Nantasket Service Station, but perhaps not in the *c.* 1960 incarnation, above, at 401 Nantasket Avenue. The old gas station had two service bays and sold Mobil gasoline. The station, owned by Haig Neal and Robert McNamara, shown on the facing page, moved in 1966 to the corner of Atlantic and Nantasket Avenues, where it remained until it closed in 1988. The new Neal's Nantasket Service Station had one large service bay and sold Quincy-brand gasoline; its location at the entrance to Nantasket Beach made it a landmark to residents and tourists alike. Following the departure of Neal's from 401 Nantasket Avenue, the building continued to contain automotive-related business until Mobil Oil Corporation sold the property to the Hingham Institution for Savings in 1975. After renovations and the addition of a brick facade, it became the bank's Hull branch, which it remains today.

The former Neal's Nantasket Service Station at 288A Atlantic Avenue sat vacant for several years, while developer David Bowering considered using the site as an entrance to a proposed hotel atop Atlantic Hill. Businessman Paul Gratta purchased the property in 1991 and the former gas station now houses the Hull Bait & Tackle Shop. Other places to fill your gas tank included Bill's Service Station at the entrance to Nantasket Pier, Smiley's Gulf at 334 Nantasket Avenue (now part of the Hull Redevelopment Authority property), Waveland Service Station at 663 Nantasket Avenue, Wanzer Gasoline at Allerton, and Jim Mascioli's Service Station at Nantasket Avenue and R Street. The only surviving gas station is Hull Mobil at 437 Nantasket Avenue, which for years was owned by the Berman family and pumped the American brand of gasoline.

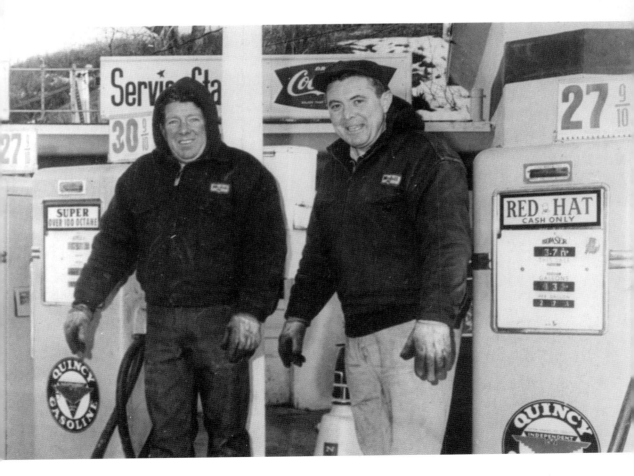

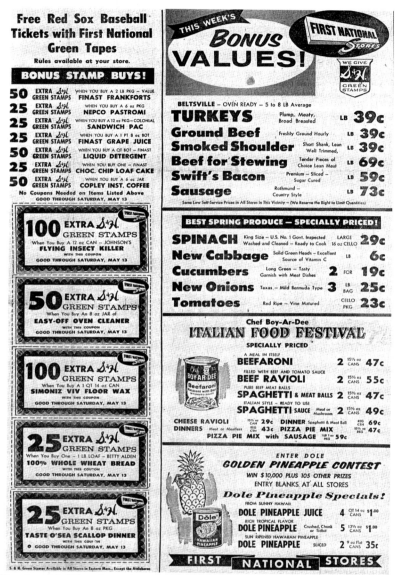
For a town of its size, Hull has been home to a dizzying array of grocery stores, neighborhood markets, and specialty food shops during the past century. In the days when cars were still a luxury and the icebox was the most modern kitchen appliance, daily trips to the corner store were practically mandatory. Markets, large and small, thrived in each neighborhood—from Walter Corkum's tiny shop in Rockaway to the 17,000-square-foot Tedeschi's Supermarket at Surfside. The 1957 opening of Tedeschi's, a distant cousin of today's chain of convenience stores by the same name, was hailed by *The Hull-Nantasket Times* as "the greatest news event in the business and civic history of Nantasket." Disagreeing with that assessment, we assume were the operators of Mercurio's Market at 45 Main Street in Hull Village (shown on page 43 in the late 1950s), the American Kosher Delicatessen at 525 Nantasket Avenue, the First National Store at 265 Nantasket Avenue, Atlantic Hill Market at 248 Atlantic Avenue, Pete's Variety at Allerton, Waveland Market at the corner of A Street, and the many other shops that catered to the needs of Hull's diverse population.

Today, the small neighborhood markets scattered around town are virtually a memory, much like the S&H Green Stamps promotion in the 1961 First National ad. The town's only grocery store is Riddle's Supermart, located at 505 Nantasket Avenue in the heart of the Kenberma district. The business is owned by Raymond Riddle, who bought the Schiffman family's So-Low Market in 1986. The Waveland has been transformed into an outpost of Tedeschi Food Shops, the Atlantic Hill Market is part of the Marylou's News chain, and Cumberland Farms has two locations—one at Monument Square and the other at the corner of Nantasket Avenue and R Street. The others? Some were replaced by other retail operations and many of the smaller storefronts along residential streets have been incorporated into private homes.

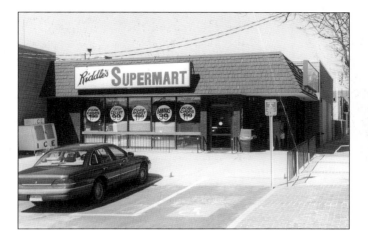

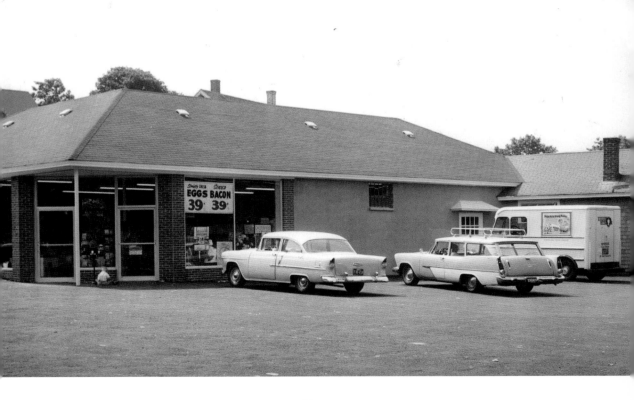

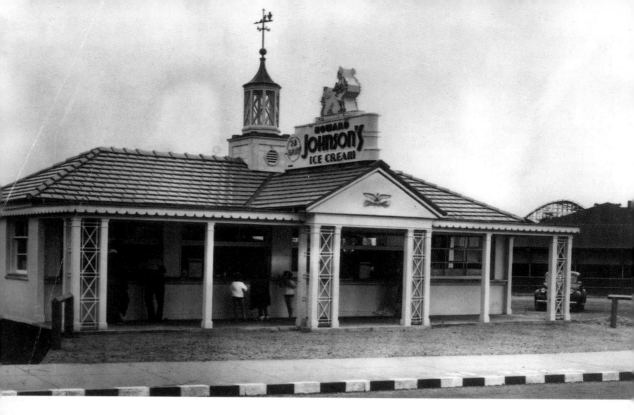

Getting an ice-cream cone at the beach has been a favorite pastime for generations of beachgoers, and, for more than 50 years, visitors to Nantasket Beach could chose from among Howard Johnson's famous 28 flavors. The shop at 121 Nantasket Avenue was among the first opened by Howard Deering Johnson of Quincy as he built his international restaurant empire. The building, with its trademark cupola and Simon the Pieman logo on the sign, is shown above in the 1930s and on the upper right side of the 1978 aerial photograph on the bottom of page 45. In the foreground of that view is the Sea Shore Motel, at the corner of Rockland House Road.

In 1981, the Howard Johnson's building and the empty lot behind it were transformed into the Nantasket Waterslide, in which riders climbed five flights of wooden stairs to ride dual blue flumes into a pool at the bottom. The building's orange roof was removed and became the snack bar and arcade for the amusement complex, which also featured batting cages. Today, this scene has changed dramatically. The motel remains, although the H&B Package Store in the bottom left corner has been replaced by a single-family home that was moved from Jerusalem Road in Cohasset. The large cliff-side home with the circular driveway is now part of the Sea Watch condominium complex, at 20 Rockland House Road. Howard Johnson's is long gone, as is the white-roofed Nantasket Antique Center, just north of the ice-cream shop. These buildings and the water slide were

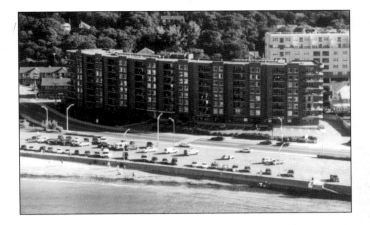

demolished in 1986 by Intercontinental Development, which built the Ocean Place condominiums on the site. The complex, which mirrors the curve of the street, is one of the high-rise condominium structures built along Nantasket Beach during the mid-1980s.

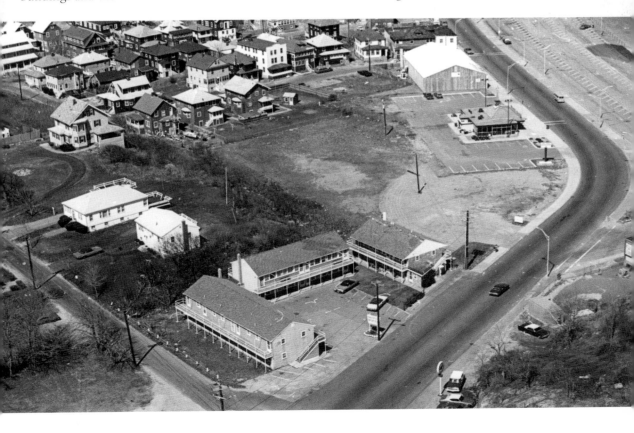

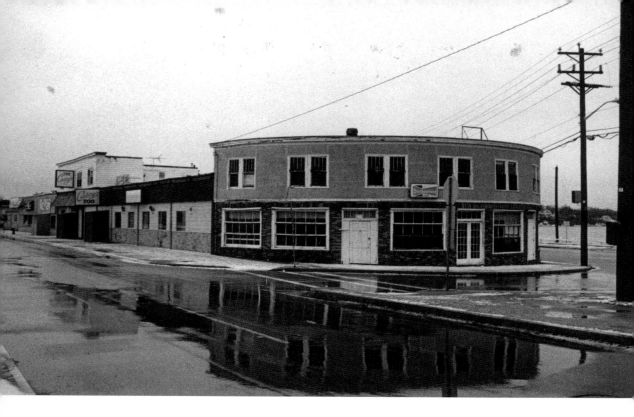

Most business names refer to products or proprietors; few can distinctly identify the enterprise's physical structure. The centerpiece of the older photograph, above, is, appropriately, the Circle Cafe, the rounded building at 1 Bay Street. This view dates from the early 1980s, shortly after the cafe closed and just before developer DX Trust proposed replacing the entire block with Murray Plaza condominiums. Looking down Nantasket Avenue, Casey's, Casey's Too, and Replay Arcade are visible—all with wind guards around the doorways to allow them to remain open during the winter. Casey's, opened by the family of former world heavyweight wrestling champion Steve "Crusher" Casey in 1976, featured a bar on one side and a wrestling ring on the other. The establishment was run by the Caseys until 1994, when the property's new owner reconfigured the layout to accommodate a Dunkin' Donuts franchise. The arcade (renamed and long closed) and Casey's were removed to make way for Hull's first drive-through, take-out window. Anchoring the block at the far end is the Oasis restaurant at 245 Nantasket Avenue, which over the years has been known as the Patio, Crossing Grille, Dick Miller's Lounge, Spider's Pub, and Atlantic Bar & Grill.

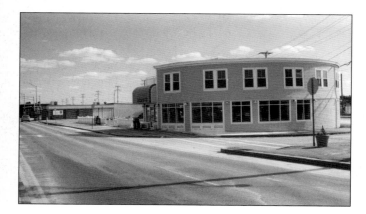

Although absent from the local landscape for more than 25 years, the Hastey Brothers market and hardware store, shown below *c.* 1911, was a Hull institution for about three quarters of a century. In its modest storefront at 325 Nantasket Avenue, Hastey's adapted from a neighborhood variety store to a hardware operation as times and shopping habits changed during the years. Anastos, which in 2001 relocated from the corner that shares its name, now occupies larger quarters at 512 Nantasket Avenue, former home of David and Doris Miller's Eastern True Value Hardware. Members of the Bornheim family, relatives of longtime proprietors Ernie and Achilles Anastos, now operate the store, which is part of the Kenberma Place retail and residential complex being constructed by developer Fred Kiley. Through the years, the community has supported several five-and-dime stores and hardware businesses, among them

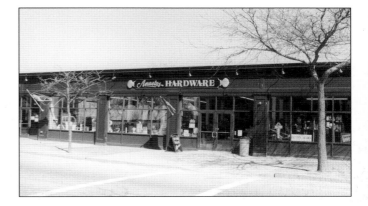

Allerton Hardware, ABC Hardware, Gills Brothers Paint, and Walsh & Packard. Even retail giant Sears, Roebuck & Company operated a seasonal store at 798 Nantasket Avenue in the 1930s. The Hastey's property, on the bay side of Nantasket Avenue, was among the 33 acres cleared by the Hull Redevelopment Authority for urban renewal in the 1970s.

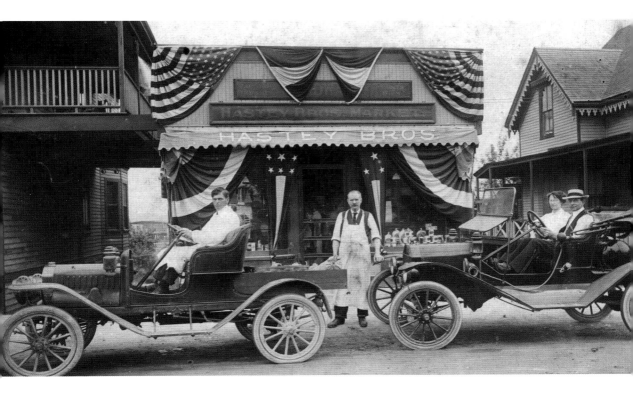

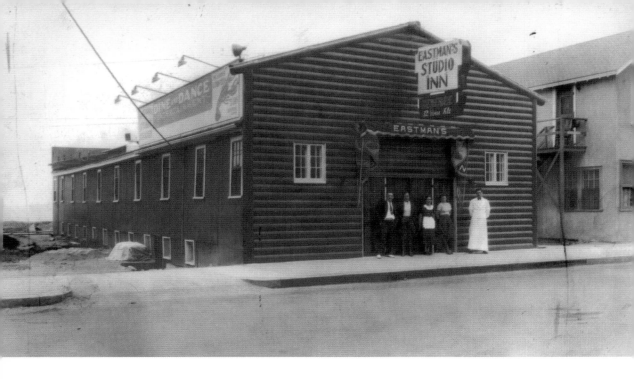

Eastman's Studio Inn, shown above c. 1940, was a restaurant and lounge and featured live entertainment and "delicious shore dinners," according to an advertisement of that era. Its owner, Jack Eastman, operated several businesses in town besides the Studio Inn, including the Pemberton Inn, a small hotel at Surfside, a breakfast-and-lunch restaurant, and a gambling club at Clam Alley (near Bay Street) during Prohibition. Most notably, the Eastman family owned the Worrick Mansion at 36 Nantasket Avenue from 1939 to 1984. In the photograph outside the Studio Inn are, from left to right, Jack Eastman, his daughter Dorothy Dimond, an unidentified employee, and Eastman's sister, Ruth Eastman, and son-in-law, Harold Dimond. The long, narrow building at 280 Nantasket Avenue—once a bowling alley—is today known as the Dry Dock, owned by the McMenimon family since 1978. In the years since Jack Eastman converted the building to a restaurant and lounge, several similar establishments have operated there, some retaining "Studio" in the name. The best known of these later incarnations was Billy Mitchell's Post Time, the immediate predecessor of the Dry Dock. Billy Mitchell was the stage name of entertainer William Guerriero; he was unrelated to the Mitchell family of Hull Village.

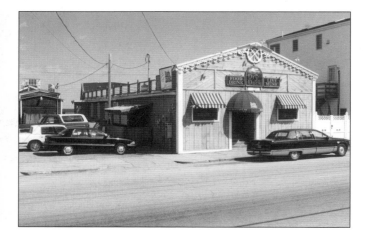

Of Hull's local neighborhood gathering places, the Gunrock House on Atlantic Avenue probably is the town's oldest continuously operating restaurant and lounge. For more than a century, diners have enjoyed stunning ocean views from the "Gunny," located at the corner of Montana Avenue, directly across from the steps down to the sands of Gunrock Beach. The business, which dates from the late 1800s, has retained its name despite changes in ownership—and architectural details—through the years. In the 1950s and 1960s, it was owned by John and Geraldine Infusino (who even named their German Shepherd dog Gunny) and served shore dinners and fresh lobsters. In the 1970s, James White owned both the Gunrock and Sweeney's, farther up Atlantic Avenue.

The Kelly family now owns the two-story building at 175 Atlantic Avenue, which has a restaurant on the first level with living quarters on the second floor.

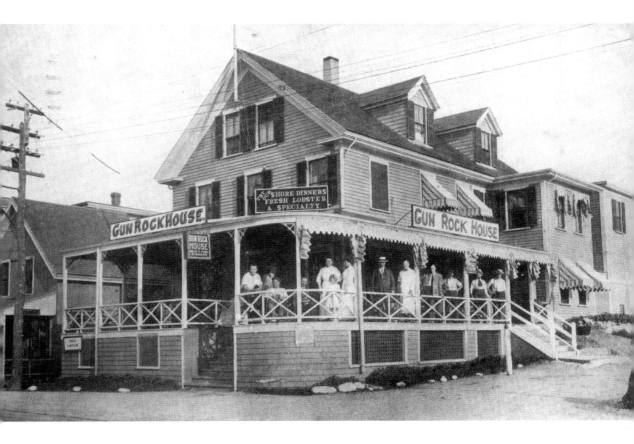

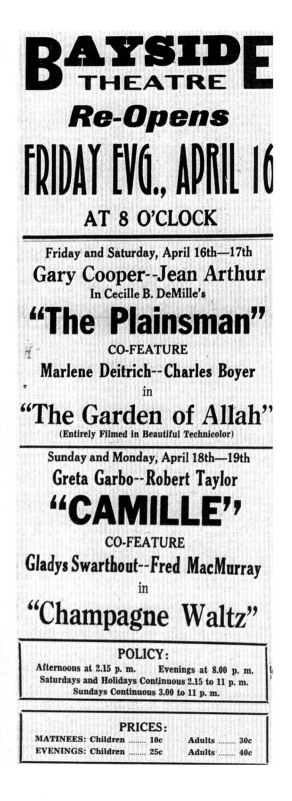

BAYSIDE THEATRE

Re-Opens

FRIDAY EVG., APRIL 16

AT 8 O'CLOCK

Friday and Saturday, April 16th—17th

Gary Cooper--Jean Arthur

In Cecille B. DeMille's

"The Plainsman"

CO-FEATURE

Marlene Deitrich--Charles Boyer

in

"The Garden of Allah"

(Entirely Filmed in Beautiful Technicolor)

Sunday and Monday, April 18th—19th

Greta Garbo--Robert Taylor

"CAMILLE"

CO-FEATURE

Gladys Swarthout--Fred MacMurray

in

"Champagne Waltz"

POLICY:

Afternoons at 2.15 p. m. Evenings at 8.00 p. m.
Saturdays and Holidays Continuous 2.15 to 11 p. m.
Sundays Continuous 3.00 to 11 p. m.

PRICES:

MATINEES: Children 10c Adults 30c
EVENINGS: Children 25c Adults 40c

There's no business like show business, and the town's longest-running productions took place at either end of town—the Bayside Theatre in the Alphabet section and the Apollo Theatre at Anastos Corner. According to news accounts published at the time of a grand reopening in 1974, the Bayside's founder was Daniel J. Murphy, a town official who later owned the Loring Hall cinema in Hingham. The theater was believed to have opened in a renovated dance hall in the early 1900s, when the motion-picture industry was in its infancy. Like the Bayside, the Apollo Theatre showed feature films, short subjects, and newsreels. Hollywood's biggest stars— including Jimmy Stewart, Bette Davis, Charlie Chaplin, Greta Garbo, and Gary Cooper—all were seen in Hull, as the two theaters' big screens brought to life the great films of the time. Like many local businesses, the movie houses were seasonal operations in the earlier years, as Hull's population dropped sharply during the winter months.

While on their way to the show at the Apollo, many Hull kids remember first stopping at the candy counter at "Coochie" Anastos's Apollo Spa (now Anastos Corner Restaurant). The Apollo went dark *c.* 1960, although the theater was still nearly intact almost 30 years later, when a local performing arts group considered renovating it as a live theater venue. The cost for rehabilitation proved too great, however, and much of the old building was torn down. What remained was most recently used for storage, although the old sign and facade are still plainly visible on Bay Street. The Bayside remained open at the corner of N Street and Nantasket Avenue until *c.* 1970; it sat vacant for several years until new owners remodeled the interior, added a brick exterior, and reopened in time to show the filmed-in-Massachusetts classic *Jaws*. The Bayside's second engagement was not long-lasting and

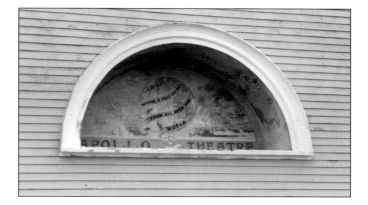

the theater opened and closed several times in the late 1970s before being sold in 1981 to the Lighthouse Assembly of God Church, which remains today. The town of Hull has not had a movie theater since the final frame of the Bayside's last picture show.

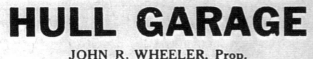

CHALLENGING ALL CARS!

Ready now...
NEW 1937 STUDEBAKERS

AMERICA'S SPOTLIGHT CARS $665 AND UP, AT SOUTH BEND

World's first cars with dual economy of Fram oil cleaner and automatic overdrive • New underslung rear axles give big roomy interiors—chair height seats • World largest luggage capacity • World's easiest closing doors with exclusive non rattle rotary door locks • World's first cars with built-in warm air defrosters Only cars with Automatic Hill Holder • World's strongest, safest and quiete all steel bodies • Studebaker's C. I. T. Budget Plan offers low time payment

HULL GARAGE
JOHN R. WHEELER, Prop.

Long before Dinah Shore's 1950s TV commercials encouraged people to see the U.S.A. in their Chevrolet, John Wheeler was selling Chevrolets and Studebakers at the Hull Garage on Spring Street. In addition to automobiles and gasoline sales, Wheeler's was a full-service garage for all makes and models. According to a 1937 advertisement, a brand-new Studebaker sold for $665 and featured the "world's largest luggage capacity," and the "world's easiest closing doors." Chevrolet that year advertised "the safest and most comfortable ride of all," with "knee-action ride and shock-proof steering." Over the years, motorists had many places to get their cars serviced, including the Hull Garage, Gilman E. Sault's Atlantic Garage next to town hall, and Ed Boudreau's Central Garage at 334 Nantasket Avenue (now part of the Hull Redevelopment Authority property). Just as the number of surviving gas stations has declined, so has the number of garages in town. Currently, Hull Mobil in Kenberma, Harbor Auto and Marine at 710 Nantasket Avenue, and Oceanside Auto at 404 Nantasket Avenue, shown below, offer auto-repair services. The former Hull Garage is now a marine shop, and the former Atlantic Garage building is owned by contractor Ernest Minelli.

As you can tell by the picture on this page, the average Hull family has not changed that much over the years. Well, perhaps a little; but you have to admit that it takes a certain type of hardy soul to live on the Hull peninsula. Sure, Hullonians are privileged—some would say spoiled—with the stunning sights, sweet smells, and soothing sounds of the sea. Yet, the people of Hull also know that the ocean is prone to sudden mood swings and that it can go from glassy tranquility to roaring fury in moments. Every generation of Hullonians has experienced its own "superstorm" (or two or three), only to rise from the rubble and rebuild again. It is then that they can get back to the things they love doing best—which for the family at Rockaway, pictured below, appears to be throwing the furniture around the yard and chasing the kids up onto the roof. The next few pages celebrate the lives of a number of the personalities who have made Hull famous in the past and some of the people who our great-grandchildren will look back upon as "true" Hullonians generations from now.

Chapter 4
STRONG MINDS AND HARDY SOULS

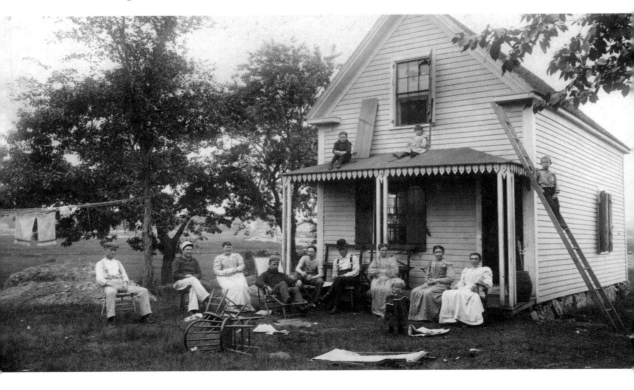

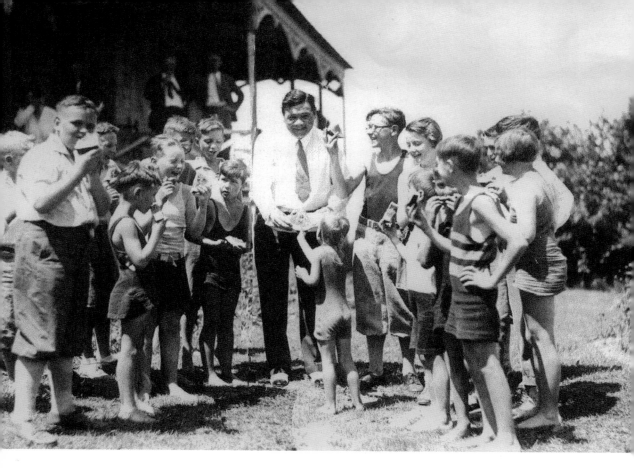

On page 105 of *Images of America: Hull and Nantasket Beach*, we told the story of the day Calvin Coolidge, Thomas Edison, and Henry Ford all met in Hull. On page 99, we showed you future president John Fitzgerald Kennedy sitting on Nantasket Beach as a baby. Pres. Abraham Lincoln got his first name from a Hull ancestor, Abraham Jones, whose daughter Sally and son-in-law Mordecai named one of their sons Abraham Lincoln, the first one in the line. So, what American personality could possibly be left to talk about in connection with Hull that could be bigger than Edison, Ford, Coolidge, Kennedy, and Lincoln? How about Babe Ruth? The Babe's legendary baseball ability was known all around the world in the 1920s. Years after his retirement, American GIs in the Pacific in World War II reported hearing their Japanese counterparts yelling "To Hell with Babe Ruth!" during battle, validating the notion that the Babe was as representative of American culture as hot dogs and apple pie. Although there have been numerous unconfirmed legends that say as much, the "Bambino" was in Hull for one day anyway. We have proof. He is shown above sharing watermelon with a group of Hull youngsters, including William Murray, who is standing tall on the left, on a hot summer's day on Green Hill. We can only hope that no Hull resident embarrassed the town by referring to the Babe that day as "the Sultan of Swat-ermelon."

In 1932, the Babe supposedly called his last World Series home run by pointing to the center field stands at Wrigley Field in Chicago in the fifth inning of game three and then driving a Charlie Root fastball to that exact spot. That same year marked the rise of the Boston Braves's young fireballer the "the Hull Howitzer" Bobby Brown, below. In his best season in the major leagues, which spanned the years from 1930 to 1936, all with the Braves, Brown pitched in 35 games, with 14 wins and 7 losses, and an earned run average of 3.30, an excellent statistic for the home run–happy 1930s. Late that season, his friends in Hull arranged with Braves's management to hold a Bobby Brown Day at Braves Field. As hitters caught up to him over the next few years, his hometown neighbors claimed that the Braves had "burned his arm out" by pitching him too often early in his career. Brown passed away in 1990. Just a few years later, Hull's Kenny Greer, right, picked up the Howitzer's spirit and began popping

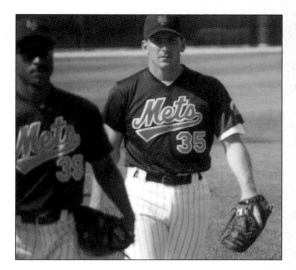

catchers' mitts in the New York Yankees farm system. Most recently, Greer, who always considered his brother Kevin to be at least his equal on the mound, was in the New York Mets system.

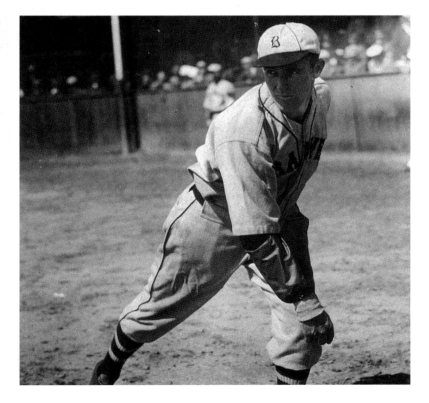

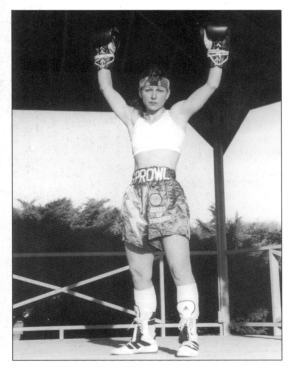

Hull's young women have fared equally as well as their male counterparts in the sports world. James Lloyd Homer, writing under the nom de plume "the Shade of Alden" in the 1840s, tells of a particular young woman in *Notes From the Sea-Shore* who excelled as a swimmer to the point of making the local men look bad. Indeed, turn of the century reports abound in stories of young female swimmers who dashed into the surf to save drowning siblings, or even complete strangers, challenging the ocean's power with their own natural physical ability. Only recently, though, have women's professional sports become commonplace in the United States, with the Women's National Basketball Association and the women's U.S. Olympic soccer and hockey teams leading the way. No sooner did women's pro-boxing come into existence than Hull had its own superstar, "Queen of Thunder" Wendy Sprowl, left. Do not be fooled by her size. Sprowl hits hard and fast, hopefully enough so to propel her to the top of her sport someday soon. Good luck ,Wendy! Parade plans are under way.

Due to the penchant for pugilism omnipresent in the stars of professional hockey in the 1970s, an old joke was revived: "I went to a boxing match the other night and a hockey game broke out." During the 1970s, Hull had its own youth hockey program, the black-and-gold-clad teams of Hull Youth Hockey. Just as HYH was winding down and joining forces with Marshfield, Scituate, Cohasset, and other regional towns to form the Seahawks, two-year-old Bobby Allen, on the left below, was timidly learning to skate. On Saturday, April 7, 2001, that same kid who was once afraid to step on the ice for fear of falling, led the Boston College Eagles to their first National Collegiate Athletic Association hockey championship in 52 years. Drafted by the Boston Bruins, Allen will turn pro in the fall of 2001, sharing the spotlight with Hull's two other budding stars, Mark Concannon, drafted by the San Jose Sharks, and Eric Healey, who signed a contract with the

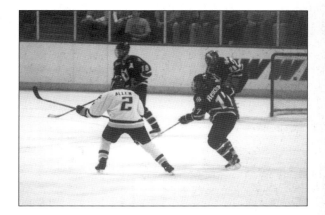

Phoenix Coyotes in 2000. All three follow in the strides of Hull's Matt Glennon, who reached the pros with the Bruins during the 1991–1992 season. For a small town such as Hull to send four hockey players to the pros in a decade is an amazing accomplishment.

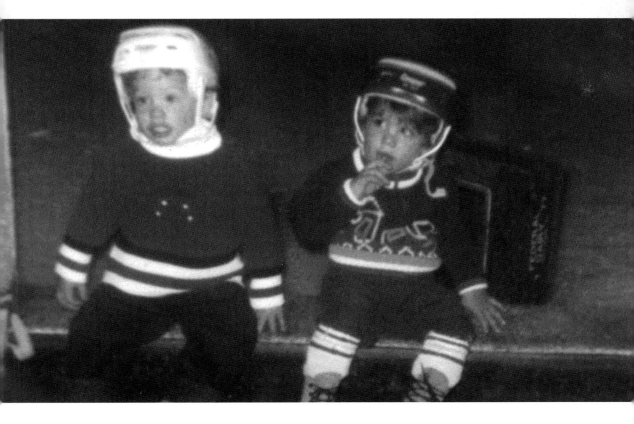

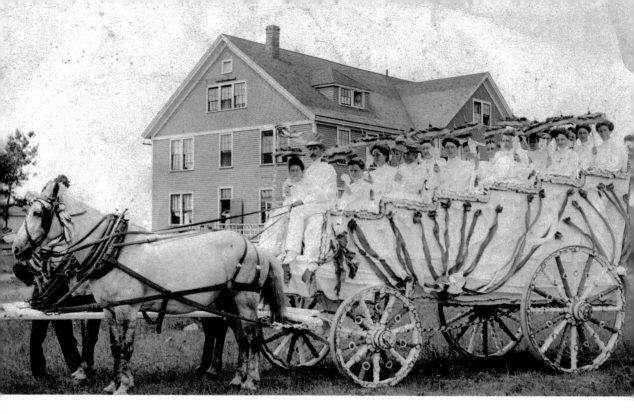

So, let's celebrate! The people of Hull saw and did some pretty strange things during the Victorian era, but then, so did the rest of the world. The photograph above came into the files of the Hull Historical Society without an explanation. The best that we—the esteemed authors—can deduce is that the fabulous carriage must be carrying a wedding party to a wedding in high-Victorian style. At least we feel comfortable in the fact that we are not alone in our confusion, as the woman in the house in the background seems equally befuddled as to what that thing in her yard is. Today, on a bright spring day, Hull's brides have the option of open-air trolleys to get them to the church on time, such as Sue Heavern chose for her marriage to Mike Richardson. Trolleys have been seen quite a bit on the peninsula over the past few years, as the Enjoy! Hull Committee has led annual summer trolley tours of the town's historic sites, from the Paragon Carousel to Fort Revere and back.

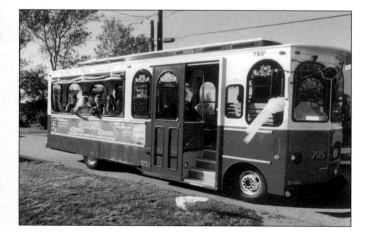

But who needs transportation? When Hullonians really want to show off, they throw a parade. Hull began its traditional Memorial Day parade just after the Civil War, as part of what was then known as Decoration Day, when families around the country visited the graves of fallen family members to adorn them with flowers and wreaths in remembrance of their sacrifice in service. Hullonians have paraded on the Fourth of July, during Old Home Week, during the nation's bicentennial celebration, on Hull Gala Days, and whenever else they have felt like it. In the photograph below, a 1937 procession passes in front of the Russell House hotel and the home of Hull's favorite (and most notorious) historian, William M. "Doc" Bergan, the author of *Old Nantasket*. To the right, Hull's beloved Gen. Richard I. "Butchy" Neal leads the Memorial Day parade down the same route passed in the 1860s. Neal rose to the position of assistant commandant of

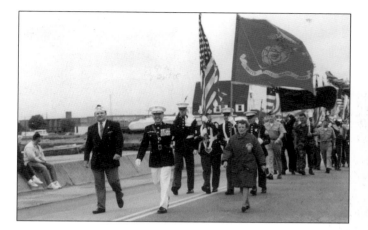

the U.S. Marine Corps before retiring at a ceremony at the marine barracks in Washington, D.C., on August 26, 1998, after more than 33 years of service. In his own words, as told to coauthor John Galluzzo for an article in the July 30, 1998 *Hull Times*, "Not bad for a kid from Hull, huh?"

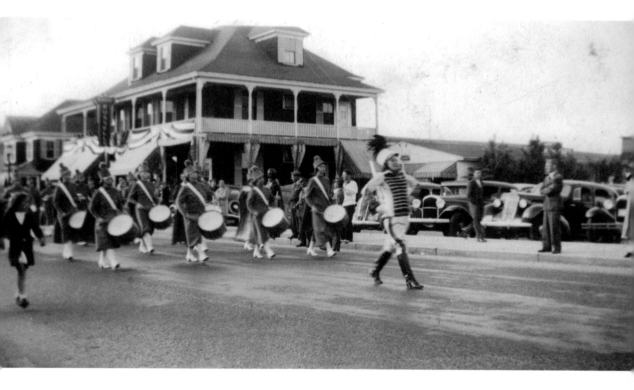

forward and directing them to safer avenues of approach." For these actions, he earned a Silver Star. Closer to home, Sgt. Joseph P. Bazinet, below here with his son Victor, was the caretaker for Fort Duvall on Hog (now Spinnaker) Island. The bridge to the island is now named for him. When the U.S. Army test-fired the 16-inch cannon on the island in 1942, they told Mrs. Bazinet to leave her windows open a crack before she evacuated to guard against the concussion, and that everything would be all right. When she returned later that night, the house was flattened.

Hull has always held its military personnel, whether active, retired, or fallen in the line of duty, in the highest esteem. Many of Hull's veterans today know the name of Myer Kendall, who served as the town's veterans agent for 10 years. Yet few people know of his decorated military career. During the Battle of Bougainville in the South Pacific, while fighting with the 132nd Infantry Division, Corporal Kendall "exposed himself to enemy fire in order to deliver rifle fire at point-blank range into an enemy pillbox, enabling a flame thrower to maneuver into position and destroy an enemy strong point, during the Battle of Hill 260. Badly wounded by a shell fragment, Kendall remained on the hillcrest, firing on other hostile positions, urging his comrades

Born in Dedham, Don Vautrinot grew up in Hull, attended the Hull Village School, and excelled as a football player at Hingham High. After three years of schooling at Northeastern University, he joined the U.S. Army Air Corps on September 27, 1940, volunteering for duty in the Philippines. Looking for adventure, he hoped to become a pilot in time to participate in any military action that might take place as a result of the aggressive nature of the Japanese Empire in the Pacific. When the war did begin, Vautrinot was captured with thousands of other Americans at Mariveles at the southern end of the Bataan Peninsula. He died in a Japanese prison camp on December 23, 1942, after enduring the Bataan Death March at 23 years old. Following the war, the town of Hull changed the names of eight streets to carry the names of its fallen heroes. Natasco Avenue in Hull Village became Vautrinot Avenue. When completed, the Hull Memorial School became just what its name implies, a memorial to those eight men. Hull also boasts a Gold Star Mother's Monument in the Hull Village Cemetery and a war memorial at the southern end of town, listing the names of all of Hull's combat veterans from the American Revolution to today.

An entertainer is not an entertainer without an audience. With the coming of the Industrial Revolution and the notion of vacations for those who could afford them, Hull became a summer gathering place for the rich and famous. Performers such as Enrico Caruso and Sarah Bernhardt sang at the Atlantic House while George M. Cohan starred at the Pacific House. Even traveling gypsies could find an audience on the crowded beaches of Hull at the turn of the century. Hull residents Susan Oberg and Harvey Jacobvitz, left, also known as Fruit and Jingles, have reversed that trend, exporting smiles to the rest of the world. Their clown wedding on May 27, 2000, drew 3,000 guests and a colorful assortment of 200 clowns. The whole affair ended up on the *Totally Outrageous* television program. As artists in residence for the Clowns of America International, they travel the country teaching youngsters how to coax out the clown hiding within and even hold a special clown camp right here in town. For more information, visit them at fruitandjingles.com.

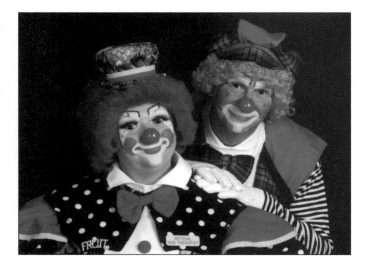

Bowen Charlton "Sonny" Tufts III, below, started his very promising acting career during World War II. Excluded from military service due to a series of old football injuries suffered while at Yale University, the 6-foot, 4-inch Boston native became a leading man in Hollywood, if only by default. According to the December 1943 edition of *Stardom* magazine, "He weighed a good two hundred pounds, topped off his perpendicularity with a head of semi-wavy and unruly blond hair, and flashed a pair of keen and

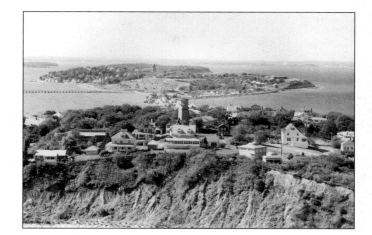

discerning blue eyes that seemed to laugh at life." His wartime roles in *So Proudly We Hail!*, *I Love a Soldier*, and *Here Come the Waves* led to parts in films such as *The Virginian*, *Blaze of Noon*, and *The Seven Year Itch*. His drinking habits eventually got him into trouble, though, and derailed his career. He was found inebriated on a Hollywood sidewalk in 1949, sued by two women for allegedly biting each in the thigh in 1950, and jailed by his wife for drunkenness in 1951. Toward the end of this career, he appeared in lesser films such as *Cat Women of the Moon*, *Serpent Island*, and *Cottonpickin' Chickenpickers*. He spent a lot of time at his familial summer home at the top of Allerton Hill before dying of pneumonia on June 4, 1970, in Santa Monica, California, at 58 years old.

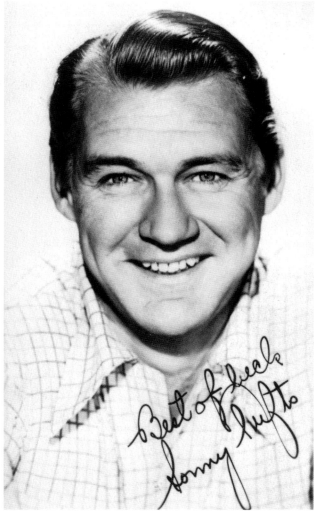

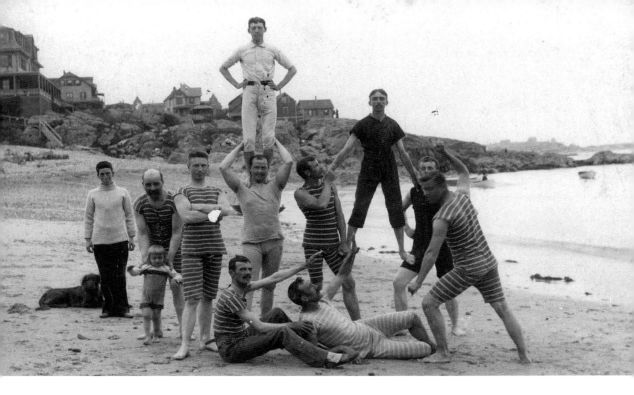

Just a passing glance up and down Nantasket Beach in summertime will reveal dozens of potential Hollywood hunks, such has always been the case. The fashions have changed over the years, from long to short to both at once, but the basic story remains the same. The beaches of Hull have always been a place to see and be seen. In the late 1930s, one Hull bather was even arrested and eventually fined for topless bathing. Imagine what would have happened had it been a woman. The Drowned Hogs have brought a little bit of summer to late winter, dashing into the Atlantic the weekend before Ground Hog Day, February 2 (an obvious attempt at stealing the Drowned Hogs' thunder), and testing the water. If they retreat to shore, winter is here to stay. If they stay in the water and frolic, spring is on the way. In 2001, they frolicked and proudly announced the coming of warmer weather. Hull then endured eight more chilling weeks of winter, with snow falling as late as April 2. Oh well.

Men like Holly the Hull Hermit, below, and Davie Moore, right, have proven that a person can have fun on Nantasket Beach without the aid of a big crowd. Although we have no recorded history of Holly's life other than the photograph, we do know that *Hull Beacon* editor Floretta Vining constantly complained of the poor fishermen who built their shanties on Stony Beach, right in front of her house in the economically-troubled 1890s. Moore, on the other hand, washed up here in Hull from an around-the-world voyage and became a fixture in our hearts. At one time the chief engineer on the *QE II*, Moore dropped it all to set off to visit every Weymouth in the world. On his way to Weymouth, New Zealand, he let hunger pains get the best of him and attempted to enter a harbor somewhere in the South Seas, unexpectedly running into a reef. Towed back to the East Coast, he landed in Hull. He soon became locally known for his pen-and-ink sketches of local scenes and annually publishes his

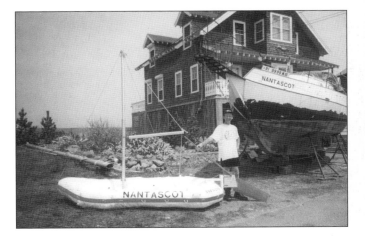

"Hullendar" calendar of his work. On a trip back to his native England in 2000, Moore acted as ambassador to the ancient town of Hull, England, for his new home. Still chasing his dreams, Moore is at work on his new boat, *Nantascot*, and may soon sail off into the distance, but if he ever needs them, he will always have a home and friends in Hull.

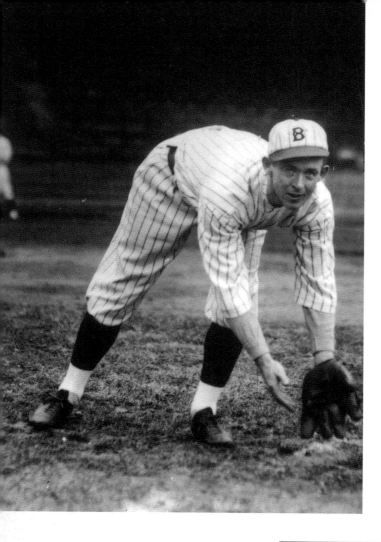

Hal Janvrin, left, joined the Boston Red Sox as a teenager, earning the nickname "Childe Harold," for the hero of Lord Byron's epic poem, but before he went pro he was a schoolboy at Boston English and spent his summers in Hull, playing in a memorable All-Star game at Fort Andrews on Peddocks Island during the 1910 Gala Days celebration. The game, contested between the Brookline Gyms and a picked nine representing the summer residents of Allerton, also featured Harvard first baseman Joseph P. Kennedy, father of future president John Fitzgerald Kennedy. The winners received silver medals. As a pro, Janvrin, who played from 1911 to 1922, set two major league records that stand today: for the most at bats in a 5-game World Series (23, tied with Joe Moore and Bobby Richardson) and for being one of several major leaguers to hit two inside-the-park home runs in one game, on October 4, 1913. The most recent player to do so was Greg Gagne of Fall River on October 4, 1986. Hull youths are still shocking the world. Shawn Fanning, pictured on the cover of the issue of *Time* magazine held by his uncle John, below, developed the Napster song-swapping Internet technology that was one of the most highly talked-about topics of the national media in 2000.

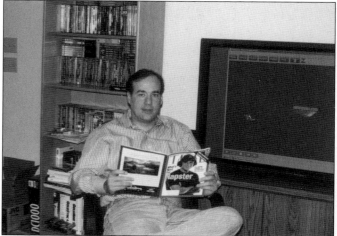

Surrounded on three sides by water, Hullonians have learned to fend for themselves in many ways. Perhaps our sense of geographic isolation tends to make us wary of outsiders, but it also helps bring us together in times of need. From the time Hull tried to secede from the United States in 1792 to today, when our biggest enemy is Mother Nature, we have always been able to close ranks and offer mutual support. During World War II, our men and women were the envy of the armed forces, if their letters home can be believed. For their first Christmas away from home in 1942, the town raised enough money to send each soldier, sailor, airman, marine, and nurse a care package that contained everything from cigarettes to backgammon. Scouts, such as the boys shown below, collected scrap iron and other usable items for the war effort. Pictured in the middle looking to the left is Bill McLearn, a former

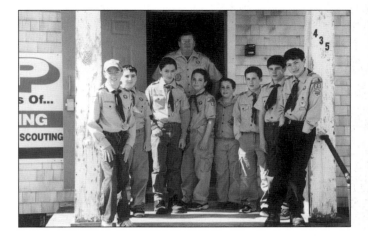

selectman. Hull's Scouts, both boys and girls, are just as active today as they were then. Soon, after the completion of their building's restoration at Kenberma, they will once again have a place of their own.

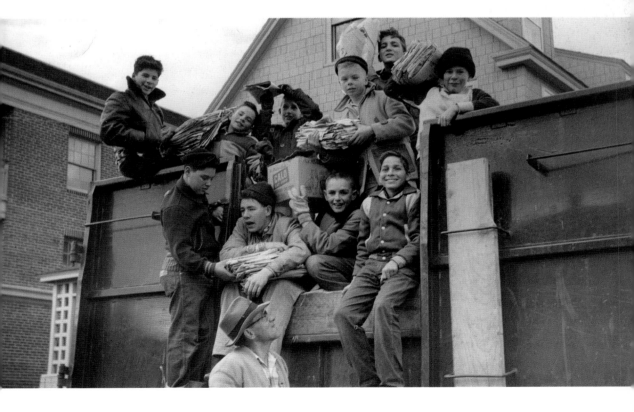

Kids have always been the heart of Hull, and it is to them that we dedicate this book. Our town is known for being politically charged, the home of many serious debates and discussions on almost every topic, but, in the end, it all comes down to our children. If we are debating education issues, it is because we want the best for our children; if we are talking about environmental concerns, it is because we want our kids and their kids to grow up in the same beautiful surroundings we enjoyed in our youth. Looking back at these pages, we see that Hull has let loose in the world generations of strong, healthy, and intelligent youngsters, all of whom have made their hometown proud. How far will these Hull children go? As far as we let them.

It is said that you can judge people by the way they treat the elderly and pets. Similarly, a town can be judged by the way it treats the buildings that serve the community—government offices and departments, houses of worship, recreational facilities, and schools. Hull takes great pride in its government and community-gathering spots. This chapter tours some of the key community buildings of Hull, showing how they have fared over the years. Although a number of these buildings have been converted from their original use to other community uses, several still serve the town proudly and with distinction. Below is one of Hull's original general stores, Rudderham & Crowley, located below Allerton Hill on Nantasket Avenue. The store sold groceries, housewares, produce, meats, patent medicines, bolts of cloth—all the necessities—and also served as a post office and a place to meet and exchange news. Venerable early models of the department store, places such as this one were essential in any community.

Chapter 5

MAKING
HULL A
BETTER
PLACE

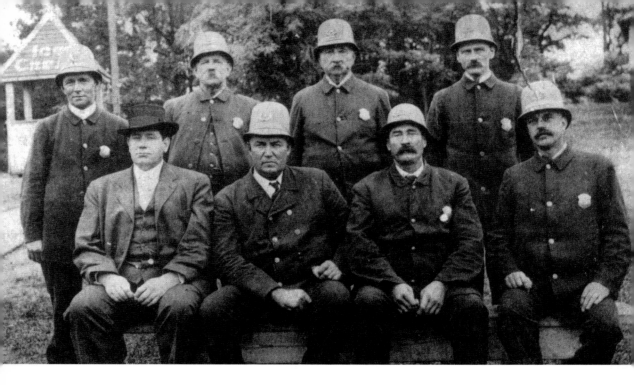

Hull's Police Department, in its early days, shared a building in Green Hill at School Street and Atlantic Avenue with the Hull Fire Department. The site of the original building is now a traffic square across from the present Hull Police Department and Hull Public Safety Dispatch Center, which is attached to the present Hull Town Hall. For years Hull's police force was a small department of a handful of officers who were augmented during the busy summer months by additional officers.

The late local political boss and community leader Dr. William M. Bergan colorfully tells of exploits of nighttime raids on purveyors of illegal alcohol and gambling dens in the classic *Old Nantasket*. As the year-round population increased, Hull's Police Department expanded and, today, it is still supplemented by seasonal police officers during the summer. It moved into the "new" Hull Town Hall when constructed in 1921, occupying the first floor until the late 1970s, when the present Hull Police Department Annex was added to the Hull Town Hall. Donald F. Brooker has served as police chief for the past 21 years. Police services these days focus on traffic and public safety and community service. A state-of-the-art communication center serves both the Hull Police Department and Hull Fire Department as the Hull Public Safety Dispatch Center, showing how far the police services have come from when call boxes and alarm whistles signaled the beat patrolman.

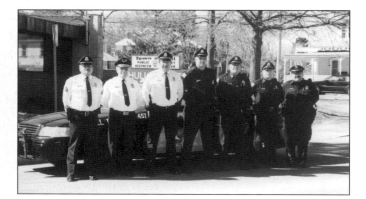

Even before paved roadways and modern infrastructure systems, every community had a local highway or public works department to keep its streets in good condition. Hull's first major public works building, below, was located on Nantasket Avenue at West's Corner, near the Hull, Hingham, and Cohasset line. The wood building, or Town Barn, as it was named, housed the stable of workhorses used for plowing, hauling, and other tasks. A modern street sweeper back then was a new broom. The Town Barn crew performed a variety of tasks, ranging from drain and road construction to maintaining the public cemetery to cleaning Nantasket Beach. The original building was replaced, at the same site, with a "modern" brick building last century. The horses have all been replaced by modern equipment. One thing that not changed with the passage of time is the variety of tasks the highway

department's hardworking men and women continue to perform. In all types of weather, they keep the roads open, clean the beaches and streets, maintain the parks and cemetery, and perform a multitude of tasks to keep the town running.

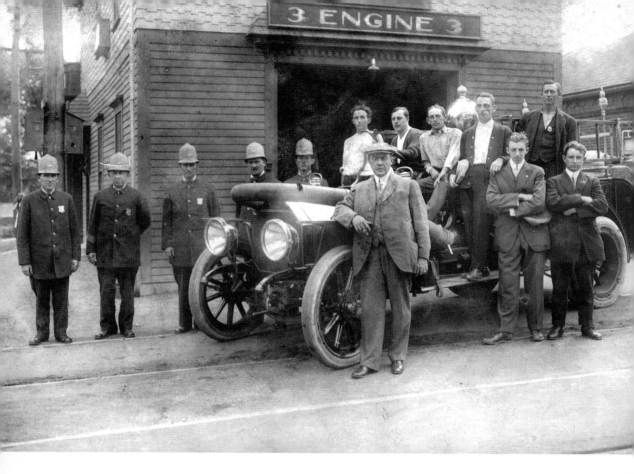

Given that so many wooden structures were built close to one another and that less attention was being paid to fire safety, it is no wonder that the Hull Fire Department was kept busy in its early years, saving structures from the ravages of flames. In its beginning, the department, like those in many small towns, was a volunteer force. Gradually, the need for a permanent force was recognized and, in 1886, it organized as a permanent fire department. Horse-drawn fire wagons shared the fire stations with firefighters. Eventually the town added mechanized firefighting equipment. Although primitive by today's standards, the town's up-to-date equipment, above, was a source of pride, especially when Hull became, in 1909, the first Massachusetts community to have a gasoline-powered fire engine. The cost at that time was $6,995, a large sum in those days. Today, modern equipment typically costs upwards of $300,000.

The Hull Fire Department, once organized, shared a building with the Hull Police Department at Nantasket Avenue and School Street on Green Hill, near the present Hull Town Hall. Eventually, the main headquarters at A Street and Nantasket Avenue was built. Substations still exist at Green Hill and Hull Village. The Hull Fire Department today, in addition to always being ready to battle blazes, operates the much-appreciated ambulance service. Most firefighters of the now-titled Hull Department of Fire/Rescue and Emergency Services today have advanced training as emergency medical technicians or paramedics. Their service today in saving lives continues the tradition of Hull hero and famed maritime lifesaver Joshua James, father of the U.S. Coast Guard. The department's uniform patch displays his image. Led by Chief James N. Russo, many members of the department have

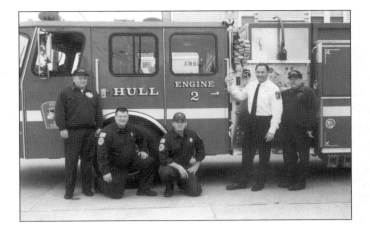

carried on the tradition of community service started by their ancestors who served on the department and in other town capacities years ago—members of the Souza, Haley, Gardner, Cleverly, Neal, and Fleck families among them.

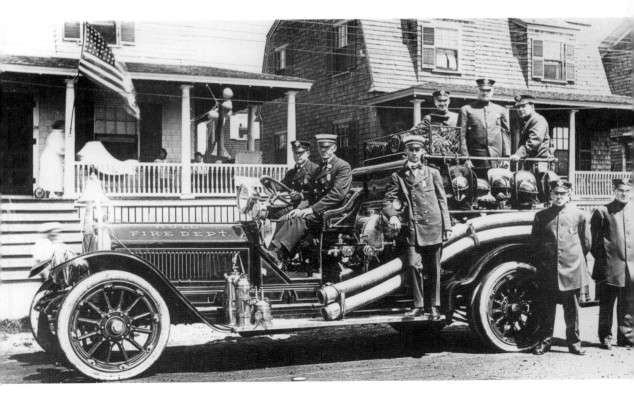

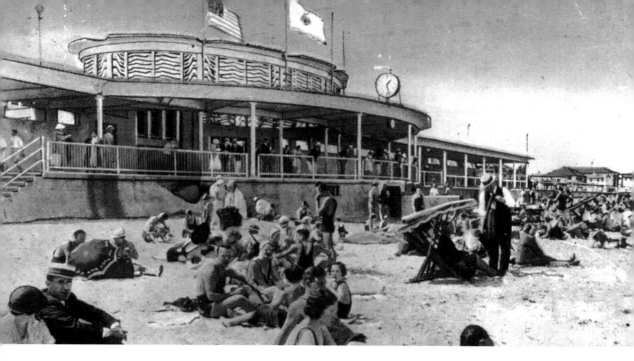

What is a beach without a bathhouse? Nantasket Beach, drawing visitors to Hull from near and far, offered a variety of amenities for beachgoers, and day-trippers. The scene above shows the Metropolitan District Commission New State Bathhouse, which opened in 1930. According to press accounts in the *Hull-Nantasket Times* of June 26, 1930, this "modern facility" had its grand opening on July 4, 1930, and was heralded as "being equipped with every modern feature of fireproof construction in every part, including the dressing and locker rooms." It replaced the prior state bathhouse at the site, which burned on Thanksgiving Day of 1929. It cost approximately $120,000. Another bathhouse, a red-roofed building at the base of Atlantic Hill, rented wool bathing suits for 5¢. Such full and complete bathing attire was required and customary—a far cry from today's styles of less and less. Hurley's

Modern Bath House, featuring accommodations for some 1,500 patrons, offered bathing suits, caps, and belts for sale or rent to the fashionably conscious beachgoer. Hurley's, whose namesake's family is still a part of the Hull community, remained a fixture in the community until it was torn down to make way for the Atlantic Aquarium. The aquarium, a victim of the gas crisis of the 1970s, closed and became the Atlantic Inn (where one could literally sleep where the fish had slept). Today, it is the site of one of the South Shore Charter School buildings. The bathhouse above and its walkway lasted for over 50 years and underwent several alterations. Finally, the Metropolitan District Commission completed a major overhaul of the aging structure, resulting in a truly modern bathhouse, left, featuring facilities for beachgoers and community space in the attractive center hall. The art deco style of the building was maintained, adding a touch of yesteryear to the scene. The building was named for now-retired state Rep. Mary Jeanette Murray in recognition of her efforts to have the state rebuild the bathhouse.

The scene below shows the beach side of the popular Nantasket Hotel, located at the center of Nantasket Beach. Nicknamed "Aladdin's Palace" because of its many towers and gables, the hotel featured some 100 rooms, all with outside exposure to take advantage of the sea air. A forerunner of the modern hotel complex, it boasted of function rooms and fancy dining rooms, featuring chefs from Delmonico's of New York. Its wide 1,000-foot-long veranda circled the entire building. A widely popular attraction was its Concert Pavilion, shown below. Visitors would spend the afternoon listening to the sounds of famous and not-so-famous bands. The building was torn down in 1955 to provide parking for the Metropolitan District Commission's concert and dance pavilion, located just a few dance steps away from the hotel site. The new pavilion, now called the Bernie King Pavilion in honor of the great bandleader, still features weekly concerts, organized by local personality and community activist Barbara Kiriakos of the Friends of the

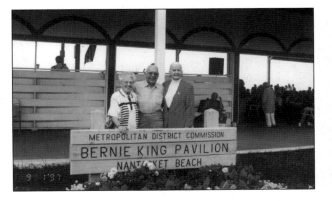

Bernie King Pavilion Association, during the weekends, much in the style of those held at the hotel. The pavilion also holds dances for young and old alike, as seen in the picture above. The community uses the pavilion for various events, including its famous Chowdafest. Some visitors who come to dance claim that when they close their eyes, they can still hear the big band sounds from the hotel concerts.

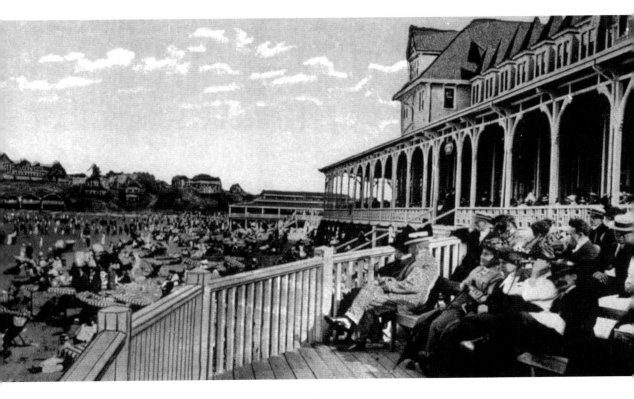

The Church of Our Saviour, Allerton, Mass.

Perhaps giving a new meaning to the spiritual effect of the sea, Hull's Church of Our Savior, shown above in the Allerton section of Hull, on Nantasket Avenue and N Street, actually went to sea. This Episcopalian church was built in 1902 and served the community until the 1940s. At that time, the church was given to the Episcopal minister from Buzzards Bay—the only condition was that he had to remove it. With Yankee ingenuity, all 70 tons of its 70-by-45-foot structure was moved to the nearby beach, placed on a barge, and floated some 60 miles to Buzzards Bay, where it still serves as St. Peters on the Canal Episcopal Church. The seafarer model over the church door, left, adds to the building's nautical history and charm.

Hull is a community noted for its diversity of faiths. One of the earliest churches, built in 1882, is now the home of St. Nicholas United Methodist Church, located on Spring Street in Hull Village, across from the Hull Village Park. A Baptist church has been located for some time on Bay Avenue East, next to A Street. Temple Israel, on Hadassah Way, was built in 1920 and is still in use today. Temple Beth Sholom, while having its Hebrew School and Community Center in its building on Nantasket Avenue, shares the use of Temple Israel for holidays and special events. Hull was also a summer retreat for the Grand Rabbi of New England's Hasidic community, which maintained a retreat at the corner of Sunset Avenue, Cadish Avenue, and D Street (now a private residence). The Lighthouse Assembly of God is located at Nantasket Avenue and N Street, in what used to be the Bayside Movie Theatre. St. Ann's Church, located on Samoset Avenue between Adams and A Streets, has remained the central spot for Catholic services. It was built in 1915 in response to the needs of the growing Catholic population, which was already making use of St. Mary of the Assumption Church, located on Green Hill (the first Catholic church in Hull when constructed in 1890), and the original St. Mary's of the Bay, also known as the Church of St. Catherine. The latter church was dedicated in 1904 and was located approximately where the entrance to the Hull Village Cemetery is today. It was razed when the new St. Mary's of the Bay in Hull Village, now a private residence, was built in 1928. St. Ann's Church, below, became the central spot for the archdiocese's activities in Hull when the other Catholic churches consolidated their operations into this beautiful sanctuary. To better serve its members, St. Ann's underwent a major renovation project in the 1990s, resulting in a greatly expanded building, as shown above, where services and other church functions are held.

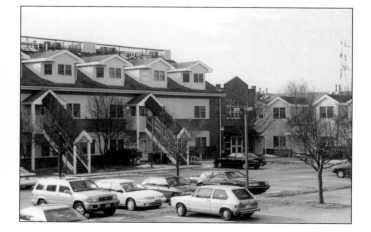

Schools have remained a central part of the Hull community. In addition to providing education, the schools were the hub of activities for the youth in the community. Opening in 1876 and being one of Hull's earliest schools was the Atlantic School, off of Atlantic Avenue and School Street. The Damon School, shown above with first- and second-grade students in 1913, replaced it in 1893. Located across from the Hull Police Department, Damon served as one of the community's primary schools until a new Damon School was built in 1959. The new school served the community until the early 1980s when it was closed. It reappeared as an important part of the community when it was converted into Damon Place Condominiums, left. If you look carefully, you can still see the general outline of the school wings. Some of the residents of Damon Place had attended the original school.

School was originally held in the old Hull Town Hall, located in Hull Village at Spring Street and Nantasket Avenue. When the Hull Village School, below, was built across from the Hull Town Hall in 1889, classes literally walked across the street to the new home for grades one through eight. This building continued to serve Hull until the Memorial School was built in late 1940s, at which time it was torn down. Some parts of the clock tower from the Hull Village School were relocated to the Memorial School. The Memorial School, located in the center of town at L Street and Nantasket Avenue, has served as a disaster shelter during nor'easters and as the site for town meetings and elections. It holds a special place in the community's heart. As this book goes to press, the Memorial School is undergoing a

$9 million renovation to bring it up to state-of-the-art standards. It will be the first school to undergo major renovations as part of a $37 million school modernization project voted by the townspeople in 1999. An architect's rendering, above, shows how the new school will look. Hull is particularly proud of the fact that then Rep. Joseph F. Kennedy spoke at the dedication. Pres. John F. Kennedy was a summer resident of Hull in his youth.

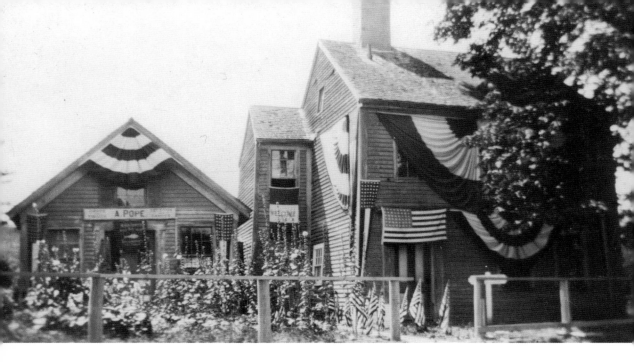

Not only did the mail bring news to people but also post offices, themselves, served as focal points of news distribution. People in Hull would often turn to the local post office to learn of the latest happenings. Over the years, Hull has had many post office buildings, several serving the community at the same time. The Rudderham & Crowley store (see page 69) and other variety stores also handled mail for the residents. During the busy summer months, additional post office locations were operated in Hull. Some of the locations, over the years, included what was Huskins at Kenberma Street and Nantasket Avenue (now a florist shop and antique store), Anastos Corner (now the home of Mezzo Mare, an Italian restaurant), and the Hull Redevelopment Authority site. Today the town has a modern main post office in the Kenberma business section and another post office in the Allerton section. The first post office is believed to have been in a 1676 house at 86 Main Street in Hull Village, while another was at the home of the Pope family, shown above in 1930 during Old Home Week. During a sudden fire in 1900, Postmaster Worster had to make her escape by leaping out of a window of the building on the left, which was then at 86 Main Street. Although altered over the years and separated from any of its former structures—many of which burned in fires—it remains today as a private residence owned by Dr. Ernest Lentini.

Any book that challenges its authors to compare the past with today will eventually lead them to realize how much has been lost or changed to the point of losing its true historical significance. Hull was once known as the home of Paragon Park, below, yet Hull High School's Class of 2003 will have lived their entire lives without the park having been open for one day. When it closed in 1985, it took with it the town's identity for hundreds of thousands of summer visitors, who for eight decades had come to Hull to ride the roller coasters, bumper cars, and ghost trains. Yet the park is only one aspect of life in Hull that has been irretrievably lost. For better or worse, the military has abandoned Hull, leaving behind the crumbling remains of Fort Revere. Luckily, as usual, Hull citizens have joined together to preserve the site and its magnificent views through the

Chapter 6

SIGNPOSTS

OF OUR

LIVES

Fort Revere Park & Preservation Society. In this, our final chapter, we will look around the peninsula at the various landmarks that have come and gone and will locate some simple reminders of what once defined our town.

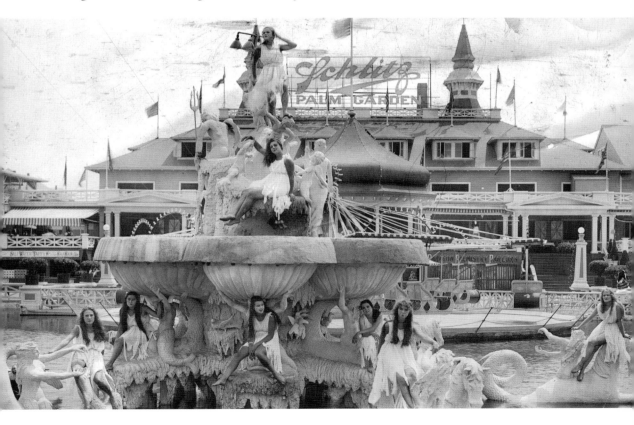

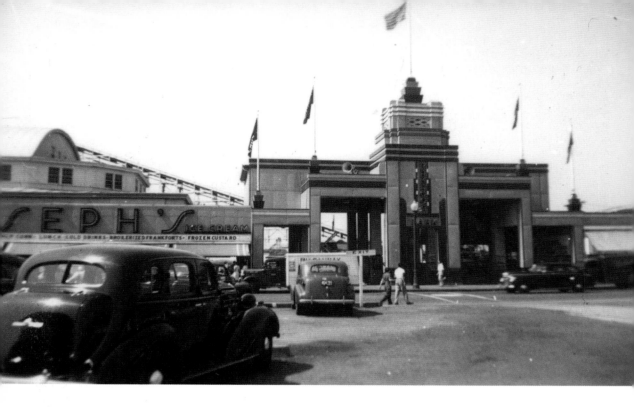

Welcome to Paragon Park. Had you visited Hull in the 1930s with the intention of experiencing the park, you would have passed through this art deco-style entrance. Opened in 1905, Paragon's advertisements compared it to a world's fair for its seemingly never-ending cyclorama of entertainment, from living dioramas of the Johnstown Flood to human torches sliding down wires into the central lagoon, where real Venetian gondoliers pushed their long boats past live band performances at the pavilion. Although the games and prizes changed over the years, nobody left the park empty-handed. Today, the site of the park's entrance is an empty space, but the flavor of the park remains a part of a Hull summer. Sodas, hot dogs, ice cream, and cotton candy can still be purchased from vendors along the boardwalk, and youngsters can still test their skill at Skee-Ball at Dream Machine arcade or their putting prowess at the miniature golf course.

When Paragon Park opened in 1905, it became an instant sensation. In the *Hull Beacon* of July 14, 1905, one writer described it as "The Electric City by the Sea, the Mecca of all New England: The great summer amusement resort of New England is, without doubt, Paragon Park, an electrical city of pleasure nestling down between the river and the sea at Nantasket. Cool breezes always blow across the narrow strip of sand to the Park and so nature adds the finishing touch to the wonderland. There are twenty acres to the park and on these twenty acres are thirty shows, a beautiful lagoon, a palatial Palm Garden, an electric tower carrying 20,000 lights and 100,000 are

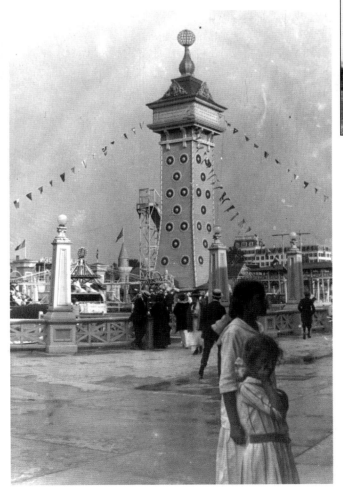

distributed throughout the various parts of the grounds." That tower is now gone, but, by a curious coincidence, Hull is now also recognizable for a set of twin radio relay towers, above, owned by WBZ Radio. According to newspaper accounts from 1939, the power generated to begin their operation came from either the splitting of an atom or more likely the stripping of an electron from an atom, making Hull possibly the home of the first use of atomic power.

Paragon's Giant Coaster was a rite of passage for generations of New England teenagers, once they reached the line on the "You must be this tall to ride" sign and no longer had an excuse to avoid it. After heeding the advice on the "Hold on to Your Hat" warning signs—good advice for anybody visiting Hull—the view climbing the 98-foot-tall first hill was unparalleled: the ocean and Nantasket Beach to the left, the bay and World's End to the right. Half the riders screamed as the train went over the top. Hurtling back to Earth, you were airborne, rising and falling with every dip, as you raced through the twists and turns at 60 miles an hour. After one unforgettable minute, you were never happier to be alive. Once back on solid ground, you had a choice: explore the rest of the park and maybe take a ride through the Bermuda Triangle or get right back in line and do it all again. One Hull resident was disappointed to find that when the park closed he could not bid on the Bermuda Triangle's big blue head, left. He had dreams of mounting it on his hillside property, overlooking the old grounds of the park.

Like the Gateway Arch over St. Louis, everyone who saw the Giant Coaster on the horizon knew where they were heading. The Giant was a perennial member of the Roller Coaster Enthusiasts of America Top Ten Lists. Such was its reputation that when Paragon Park was auctioned, another amusement park spent $1 million to disassemble and reconstruct the legendary coaster in Largo, Maryland. Now called the Wild One, the ride continues to be a popular attraction at Six Flags America, but the thrill is not the same. Paragon and the Giant were too much a part of one another to transplant the magic to another place. Still, the excitement of the old coaster was caught one last time in the picture on the right, during the inaugural Maryland ride.

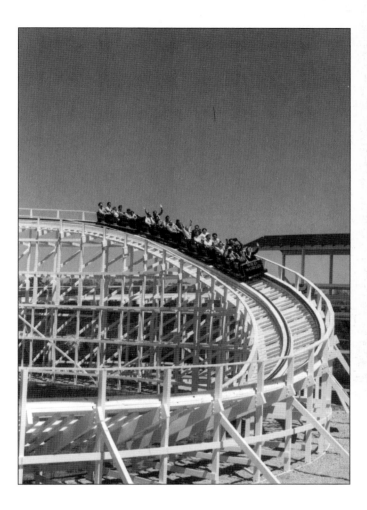

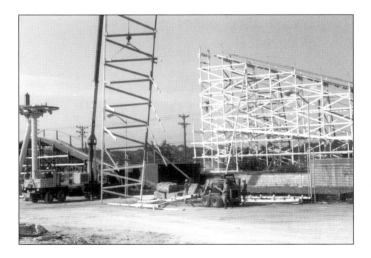

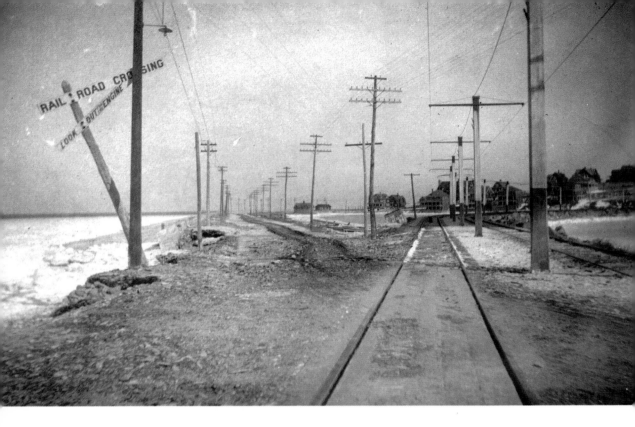

The people of Hingham once described Hull as the "Moon Village at the end of the Earth." Admittedly, they were not too far off. You do not know the meaning of impassable until you have tried to get past the Stony Beach isthmus during a good nor'easter. Before the coming of the train in 1880, the stretch of land between Allerton Hill and the village routinely washed over at high tide. The early history of Boston Light includes a mention from the Massachusetts General Court for an investigator to go to "the island of Hull" to scout out a location. Even as late as 1872, burial agent Lewis P. Loring decided to transport the bodies of the sailors killed in the wreck of the bark *Kadosh* on Harding's Ledge to Hingham rather than try to pass the isthmus with a horse-drawn cart. The construction of the train trestle late in 1880 and then the extensive filling on the south side of the spit in the 1930s to accommodate the relocation of the Old Beacon Club from Allerton Hill to Windermere transformed the area to what it is today. The tearing up of the tracks in 1937 opened up the road that became known as Fitzpatrick Way, for World War II casualty Charles Fitzpatrick, to the right at this intersection.

Trains, first steam-driven and then open-air electrics, ran the length of the Hull peninsula. The track came in stages: from the Nantasket Steamboat Landing to Allerton Hill and then from Allerton Hill to Windmill Point and then from the landing to Hingham, where it connected with the rest of the South Shore. The original track ran from the steamboats to the hotels, with no need of contact with the outside world. The second leg took a curious route around the outside of Souther's Hill, rather than taking a more protected trip through the center of Hull Village. Curious, that is, until you learn that the people of Hull wanted no part of a big, noisy, smelly train passing through their quaint village. For years, storms tossed boulders onto the tracks, disrupting train service until they could be moved. Little remains today to remind us of Hull's locomotive past. Just north of this station, at the southern base of Allerton Hill (who put the baby on the tracks?), the old right-of-way begins, a hotly-contested strip of land for more than 60 years. On the right, the view overlooking Fort Warren on George's Island shows the concrete stairs that once led to the platform of the Hull Station, which now lead nowhere.

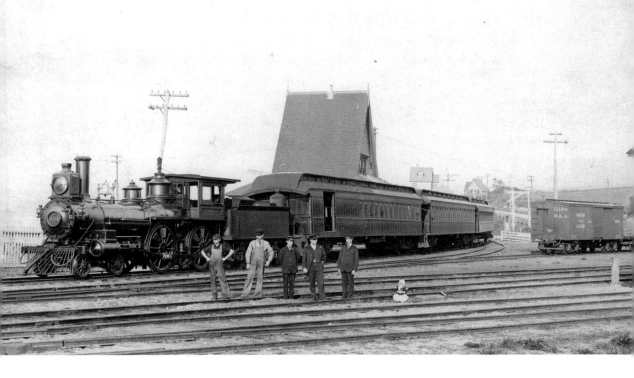

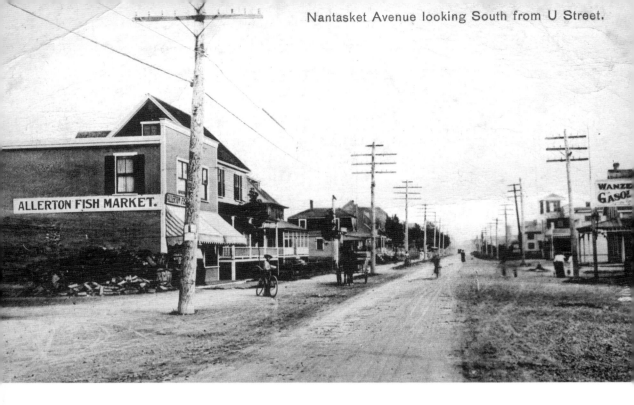

ALLERTON FISH MARKET.

WANZE GASOL

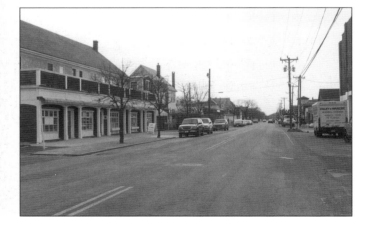

A dusty road on a summer's day beckons. At first, the entirety of what was known as Hull consisted of a cluster of houses between Hull and Telegraph Hills at the end of the peninsula. Soon, a second fishing village began to grow at the southern end of town. Even through the 1820s, though, the land between Atlantic and Allerton Hills was known as "the Plains" of Nantasket, a wide, treeless stretch of land covered in brush, perfect for duck hunting. Even statesman and orator Daniel Webster enjoyed such adventures in Hull. As time passed, pockets of land began to be inhabited by folks who proudly referred to themselves as residents of sections of town rather than by the town itself: Allerton, Kenberma, Surfside—each a stop along the train line. In the view on the left, looking south along Nantasket Avenue, we can see that several structures remain from those early dirt road days and that certain businesses, in different incarnations, still serve the town.

Coming into town from the other direction, we see a view of the town, below, shortly after the Metropolitan Park Commission takeover of Nantasket's "Golden Mile" in 1899. With the beachfront in pieces after the *Portland* Gale of 1898, the state of Massachusetts saw the opportunity to rebuild the waterfront to respectability by stamping out the corruption, pickpocketing, gambling, and prostitution for which Hull had become famous in the 1890s. One Boston writer responded to the debauchery at Nantasket by referring to the town's motto, gained in the 1840s after a last-minute Hull voter swung an entire election, "As Hull goes, so goes the state." He then added that if that be the case, "Then God save the Commonwealth." Although maybe not as picturesque as the older photograph,

today's drive down Nantasket Avenue, above, still offers an ocean view as it did in the early 1900s, and the smokestack on the left is replaced each winter by a scraggly Christmas tree outside the Mary Jeanette Murray Bathhouse.

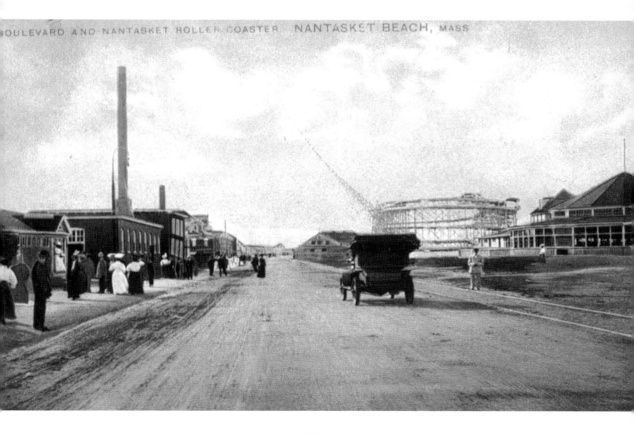

BOULEVARD AND NANTASKET ROLLER COASTER NANTASKET BEACH, MASS

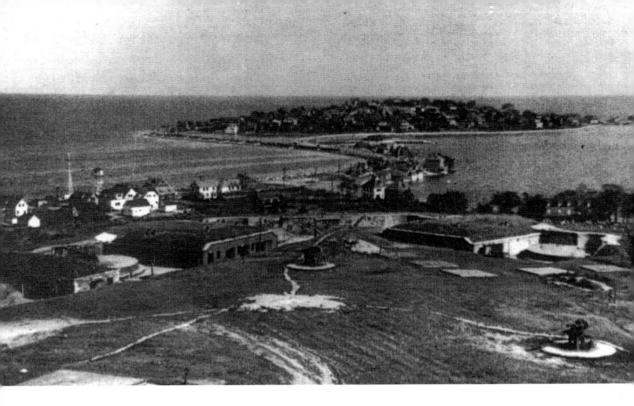

The view from Fort Revere on Telegraph Hill may simply be the most beautiful oceanside scene on the South Shore of Massachusetts. Taken in from the top of the Fort Revere Water Tower, it becomes even more breathtaking. The above photograph, taken from the tower *c.* 1942, shows Batteries Sanders and Pope, with two three-inch .50-caliber antiaircraft guns in the middle ground with one of Battery Sanders's disappearing rifles. The six-inch guns of these two batteries were sent to France during World War I, but only Battery Sanders was rearmed after that war. In 1943, the six-inch guns were scrapped and the observation and fire control tower was built on Allerton Hill on the Tufts Estate. Today, the gun mounts of Battery Pope serve as stages for plays and concerts. The park is a good example of what can be accomplished by volunteers working with both the town and the Metropolitan District Commission to protect the site.

Looking out toward Stony Beach, the view below shows Fort Duvall on Hog Island, once home to the two massive 16-inch guns of Battery Frank S. Long. These powerful weapons had the capability of thrusting a 2,000-pound projectile an extreme distance of 30 miles. The island derived its original name from the early colonists, who kept hogs on the island, making use of the natural water barrier for fencing. Development plans at the end of the 19th century called for summer homes and bathhouses and a renaming of the island to Park or Vista. The army was not so name conscious when Fort Duvall was built in the 1920s, so the old island name remained. During practice firing of the guns in 1942, residents of the town were warned to tape their windows and to evacuate the area from Stony Beach to D Street. The concussion caused by the firing of the

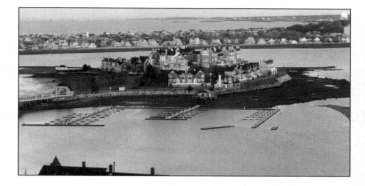

guns led to the army receiving $5,000 worth of claims for shattered glass from the townsfolk. The Joseph P. Bazinet Bridge, one casemate, and the underground bunkers are all that remain of Fort Duvall, now known as Spinnaker Island, above. Although it would have been preferable to keep the historic name of the island, who would have bought a condominium on Hog Island?

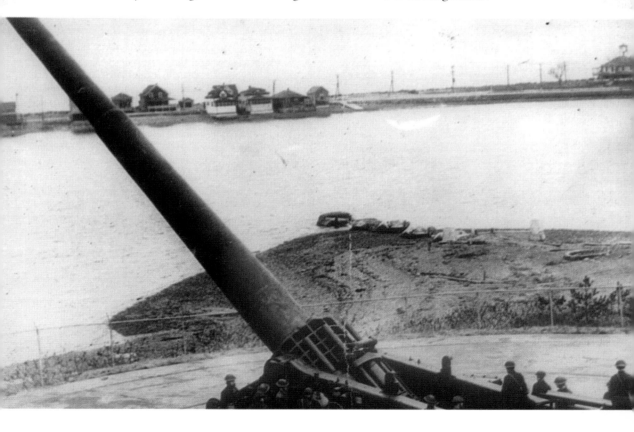

In 1900, the Hull Village Cemetery was known for its beautiful American elm trees and was the only wooded spot in town. Today, the cemetery has no trees, while the rest of the town has filled in. Following the *Portland* Gale of 1898, the people of Hull finally made the decision to construct what they called a "receiving tomb" for the cemetery. They noted three reasons why such a tomb should be built. First, when unidentified sailors washed ashore, as more than a dozen did during the *Portland* Gale of 1898, the tomb could act as a storage facility for corpses until such time as they were either identified or buried. Second, bodies could be stored inside when the ground was frozen and burial had to be delayed. Third, storing a body for two or three days before burial gave the apparently deceased an opportunity to wake up, a tradition from which today we have the wake. The Hull Village Cemetery has many more stories to tell, some of which may never be heard again. For instance, who knew that a recipient of the Congressional Medal of Honor, the highest award that can be earned by an American in the military, rests there? Albert L. Knight earned the honor during the Battle of the Crater, Petersburg, during the Civil War, while fighting with the 5th Regiment of Vermont Volunteers.

ore! At the end of the 19th century, Hull, along with the rest of the United States, caught golf fever. In fact, the town at that time had more than one golf course. The Atlantic House had a few holes on its grounds, while the Rockland House set up seven as well. At the far end of the peninsula, the Hull Golf Links proved to be some of the most challenging around, atop Telegraph Hill. When the federal government opted to begin fortifications anew at the top of the hill, they pushed the golf links aside. Trouble had been brewing there anyway, as Hullonians with cows found that the links provided the best feed for their animals and set them free to graze at will, scaring away female golfers. Today, one can still imagine what it must have been like to stand on King Rock, look seaward, try to line up a shot with Narrows Light, and let it rip onto the seventh fairway. Although the course is gone, King Rock—once a landmark for mariners,

the seventh tee of the Hull Golf Links, and still the largest glacial erratic in Hull—remains. In the 1940s, above, it apparently also served as a playground for Lt. Col. Vincent P. Coyne and his little buddy at Fort Revere.

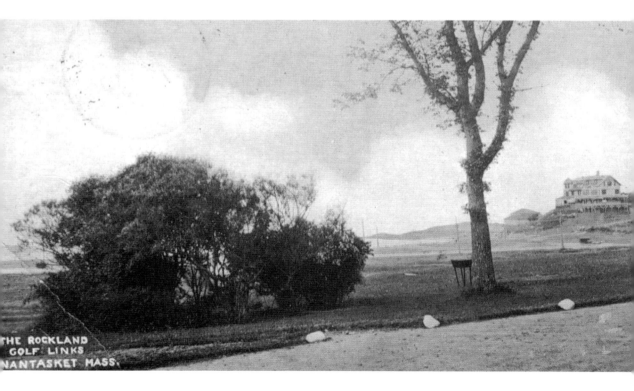

THE ROCKLAND
GOLF LINKS
NANTASKET MASS.

93

So, we come back full circle to Paragon Park, an apropos ending with our last remaining Paragon landmark, the carousel. Built in the Germantown section of Philadelphia by the Philadelphia Toboggan Company in 1928, the 66 horses and 2 Ben Hur-style chariots still delight crowds as they did at the park all those years ago, prodded on by the strains of a 1930s Wurlitzer 150 military band organ. It almost took a miracle to keep the Paragon Carousel in Hull when the park closed, and were it not for a partnership that involved Hull's Dan Prigmore, the Levin Companies, and Paul Townsend, leading the Paragon Carousel to its new home in 1985, it may never have happened. Today, in winter or summer, the Paragon Carousel reminds us of the beauty of Hull's past and our town's commitment to preserving it. It shows us that although the names and faces in town may change, in the end, together we are all merely the next link in the chain of Hull history, connected to our forefathers by our passion for the sea, the summer, and the pursuit of good times. So, we come to the end of this our second book. Aren't you proud of us? We got through the whole thing without saying, "As much as things change, the more they stay the same," even once—until now.

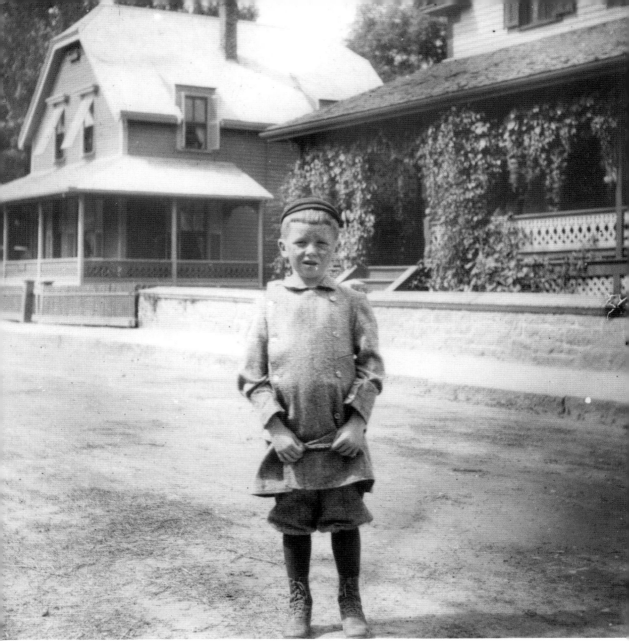

Do not let the youth of Hull stand alone. By purchasing this book, you are helping to restore the Hull Scout Building, to ensure that every one of Hull's Boy and Girl Scouts will have a home for future meetings, cookie drives, and even sleepovers. The members of the Committee for the Preservation of Hull's History will donate every cent earned from the royalties of this book to the project. The children of Hull are the future keepers of the history of our town; thanks for joining us in supporting them. Donations to the Hull Scout Building Restoration Project can be sent to:

Friends of Hull Scouting
P.O. Box 14
Hull, MA 02045

ACKNOWLEDGMENTS

Wow! An author, or in this case, some 12 of them acting as one, never knows how many people have aided in the production of a book until it is time to count heads. The following kindhearted folks helped make this book possible: Bob Dever; Dr. Robert W. Haley; Anne Murray (for the picture of Babe Ruth on page 54); the Boston Braves Historical Association; Nancy Allen; Susan Heavern-Richardson; Rose Bonanno; Muriel and Myer Kendall; Lorraine Gillis; Al Vautrinot; Susan Oberg and Harvey Jacobvitz; Davie Moore; the National Baseball Hall of Fame Library, Cooperstown, New York, (Hal Janvrin, page 66); Susan Silva; Beth Strozewski; Susan Ovans and the staff at the *Hull Times*; Paul McLaughlin; Barry and Joanne Haraden; Bill and Pat Kelley; Jim McArthur and Barbara Leveroni, Franchise Associates, Howard Johnson's; photographers Larry Hallahan and Don Roine; Gerald Butler; Al Schroeder, Metropolitan District Commission; Fort Revere Park & Preservation Society; Barbara Lawlor; Paula Gibson; Barbara Kiriakos; Doris Kaplan; Architecture Involution LLC; Hull Historical Society; Fay Roby; and Hull Public Library. If we missed anybody, we apologize. Thank you one and all.